P9-APY-461

PAUL

SEP 2 6 2006

HOW TO
PAINT FROM
PHOTOGRAPHS

THE ARTIST'S GUIDE TO TECHNIQUES AND MATERIALS

HOW TO
PAINT FROM
PHOTOGRAPHS

THE ARTIST'S GUIDE TO TECHNIQUES AND MATERIALS

TONY PAUL

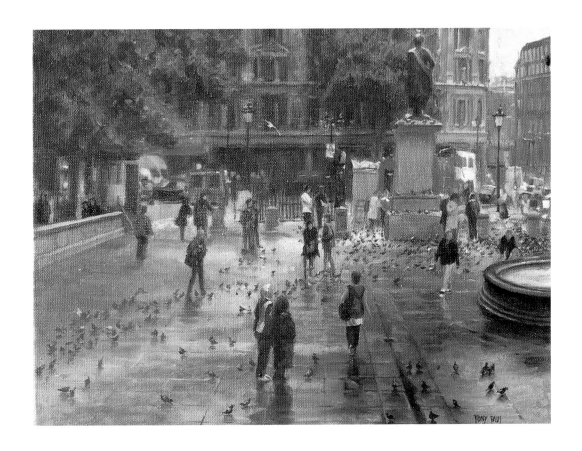

NEW
HOLLAND

Published in 2005 by
New Holland Publishers (UK) Ltd
London • Cape Town • Sydney • Auckland

Garfield House
86–88 Edgware Road
London W2 2EA
United Kingdom
www.newhollandpublishers.com

80 McKenzie Street
Cape Town 8001
South Africa

14 Aquatic Drive
Frenchs Forest, NSW 2086
Australia

218 Lake Road
Northcote, Auckland
New Zealand

ISBN 1 84537 233 6

Senior Editor: Corinne Masciocchi
Designer: Ian Sandom
Production: Hazel Kirkman
Editorial Direction: Rosemary Wilkinson

1 3 5 7 9 10 8 6 4 2

Reproduction by Modern Age Repro House Ltd, Hong Kong
Printed and bound by Times Offset (M) Sdn. Bhd., Malaysia

CONTENTS

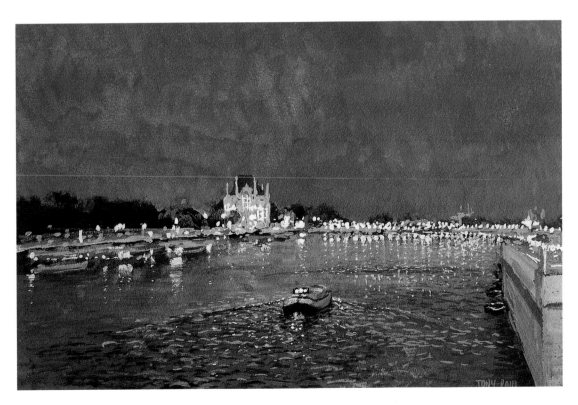

FOREWORD

As both a lifelong photographer and, more recently, a watercolour artist, I came across Tony's work some years ago in connection with the practice of egg tempera painting. His finely detailed pictures have much in common with the photographic process and this mutual interest in 'drawing with light' gave our friendship greater depth. I was therefore very pleased when he asked if I would write the foreword to his latest book.

However divided artists may be over the value of using photography to help their work, there is no doubt it has deep historical roots and has been used by many respected and famous names. The following pages do much to enhance and explain the practice, illustrating the pitfalls and offering considerable encouragement.

In truth, the most recent developments in digital photography and the enormous potential of image manipulation on the computer seem to bring the picture-making art of artist and photographer closer together than ever before. The innate skill of the artist, and the co-ordination of brain, eye and hand, do seem to me to be the superior interpretive medium, that golden opportunity to improve on the original photograph. Yet, when used intelligently, the camera remains an important tool.

Ian Aston ABIPP, ARPS

RIGHT St Georgio from the Lagoon, Venice; Tony Paul
Watercolour, 293 x 204 mm (11½ x 8¼ in)

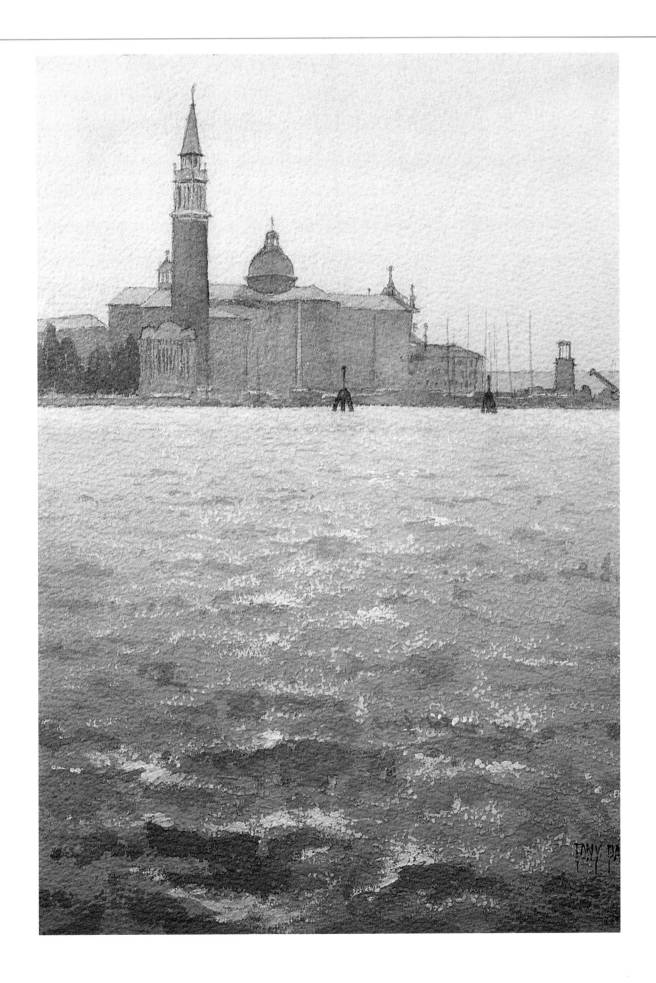

INTRODUCTION

When I first began to take painting seriously my time was limited by work commitments so I started to take photographs to use as references. I began to believe that the zenith of achievement was to bring the finish and detail of my work to such a standard that the painting looked like a photograph. My quest for this Holy Grail took a long time, but I got there. My paintings really did look like photographs.

I loved the comments people made: 'It looks just like a photograph' or 'You're very clever to make it look like a photo.' Clever I may have been, but as time went on I grew progressively more disenchanted with spending days creating a piece that looked like something a machine could do in a sixtieth of a second. I realized that there was little or no individuality in the paintings I did. I didn't feel so clever any more, and when people said how like photographs my paintings were, I began to grind my teeth with irritation.

As a consequence, I stopped painting altogether for a couple of years. When I started again, the paintings were more about subject, paint, texture and atmosphere. I found the substance of paint a delight, relishing the flow and granulation of a watercolour wash, the creaminess of oil and the graphic qualities of egg tempera.

I still used photographs as reference material, but I began to realise that they were best used as a rough guide rather than a template. As I worked more from life, I noted that photographs had bad traits – they compressed views, distorted perspective, had sometimes idiosyncratic ideas of what colours should be, and they found extremes of tone impossible.

Nowadays, I work a lot from life – it really is the best way of working. You can see things more clearly and if you can't make out what is happening in some aspect of the subject you can stop painting and go take a closer look. But the greatest advantage of working from life is that you are there. You absorb the atmosphere of the place or the personality of your sitter and, somehow, on a good day, this character finds its way into the painting. I still use photographs; they are a great tool, but I use them with care.

Sometimes photographs are the only practical way of capturing certain subjects: the wonderful view that can

ABOVE Zorro and Paquerette at Serez; Tony Paul
Egg Tempera, 305 x 406 mm (12 x 16 in)

only be seen from the middle of the road; a transient effect of light; the view from a bus or from a ship as it enters port; a loved one or friend who has passed away; a hyperactive child; or historical scenes.

And what about those who are less fortunate than most of us – the infirm, disabled, elderly or frail – who find going out to paint an impossibility? Without photographs and other two-dimensional references, they would be condemned to painting still lifes or views from their windows for the rest of their lives.

Photographic references can be used in tandem with working from life: if you fail to finish the painting from life, or the light or weather is beginning to change, or the subject is more complicated than you thought, you can carry on and finish it in the comfort of your studio with the aid of a photograph or two taken at the time.

Painting has to take its place in terms of the priorities of life; often only evenings and, perhaps, the occasional weekend are available, so painting from photographic references is usually the only option.

Even on holiday there are other priorities – children (or impatient husbands or wives) are reluctant to sit around wasting away their hard-earned break, while the artist of the family spends two hours or so indulging him/herself with a spot of painting. Isn't it so much easier to carry a camera and use a sixtieth of a second now and again to capture a few paintable images, which, upon return, can inspire paintings?

This book sets out to show the reader how to take good shots and how to use photographs successfully and creatively. It is based on my own long experience and the hope is that by taking the advice given, the reader will be spared the difficulties I had when I first embarked on my painting career.

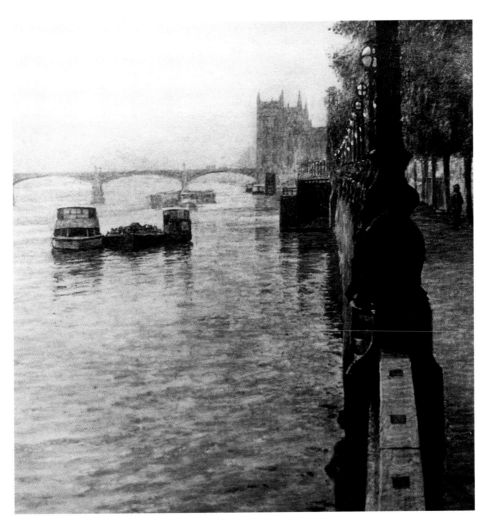

ABOVE River Thames at Westminster; Tony Paul
Egg Tempera, 235 x 203 mm (9¼ x 8 in)

PART ONE
THE CAMERA

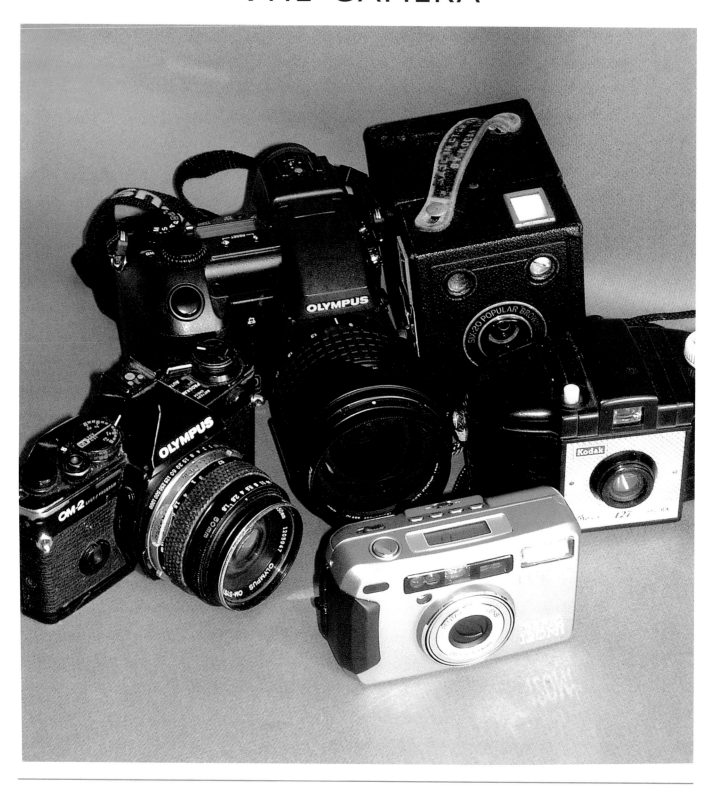

THE CAMERA OBSCURA

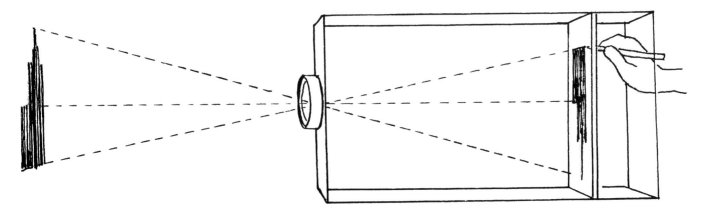

ABOVE The image enters the camera and appears as an inverted image on a ground-glass screen at the rear of the box.

Undoubtedly, one of the most difficult parts of producing a painting is the drawing stage. For the expert draughtsman, it is often considered the most enjoyable part, translating the three dimensions of the subject – width, height and depth – into two dimensions: width and height. Each drawing tests his skills of observation and the co-ordination of eye and hand.

But accurate drawing needs time and care, and a complicated drawing could take a considerable amount of time to complete. For the busy artist, any device that would get the painting up and running quicker would save valuable time and costs.

Around the late 16th century, the science of optics developed a device that would enable the artist to simply draw around an image projected by light.

A camera obscura – literally a 'dark room' – was the direct ancestor of the first photographic cameras. As can be seen from the diagrams, it was an enclosed dark space, which had a small hole (later a lens) in one side. The operator would point the device at a subject. A beam of light from the outside world would pass through the hole or lens to cast an inverted image of the subject onto the vertical surface within the 'room'. The artist could then draw around the image to give an accurate representation of the subject. It became popular as a great time saver to those who could draw and as a crutch to those who had difficulty with drawing.

It was in use by European artists by the early 17th century. As its use widened, sophisticated portable versions incorporating mirrors and ground-glass screens enabled these painters – often hidden under black cloths

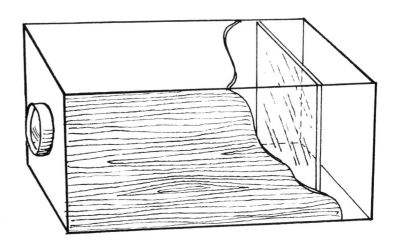

ABOVE The simple construction of the camera obscura.

to keep out the light – to use the device outside. It was a boon for topographical artists such as Canaletto, who used the device for his Venetian paintings and other complicated scenes involving townscapes.

Vermeer, too, is reputed to have used one to draw out his compositions. It would certainly have helped with the perspective of the tiled floors in many of his paintings.

Naturally, the subject had to be fairly still, as trying to draw around something that is on the move would be impossible. Camera obscuras, then, were mainly suitable for landscapes, seascapes and posed model work. They could also be used to copy two-dimensional subjects such as paintings, drawings or maps, the original being set up vertically on an easel at a suitable distance in front of the lens.

THE CAMERA LUCIDA

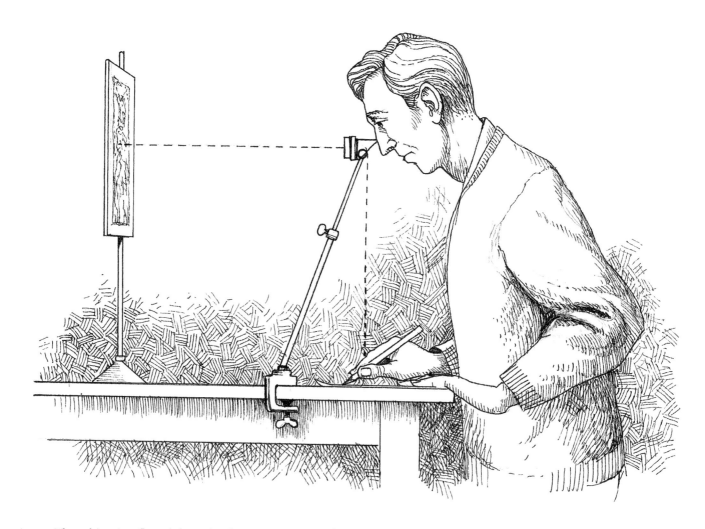

ABOVE The subject is reflected through a lens to appear as a ghost image on the paper which can then be drawn around.

The camera lucida, or light room, was designed in 1807 by Dr William Wollaston. The device was basically an arm that could be clamped to the edge of a table. At the top of this arm was a reflecting prism that was set within a lens. This would be angled to point at the subject. Drawing paper would be laid flat on the table, and the user would peer through the lens and see both the paper and a ghost of the subject to be drawn. He would then complete his drawing. Even more importantly than with the camera obscura, both the subject and the user had to be completely still, as any movement of either would end up creating inaccurate distortions.

Being difficult to use, the camera lucida did not prove to be as popular as the camera obscura, and would probably have faded away into the dustbin of art history had it not been for David Hockney's book *Secret Knowledge,* which set out to suggest that many well-known painters used the camera lucida to create their drawings. There was even an assertion that Ingres used the device. Ingres was a master draughtsman, highly skilled. He had his own art school and taught with great emphasis on drawing. Suggesting that he secretly used a camera lucida is like asserting that Olympic 100-metre runners secretly train using crutches.

THE EARLY PHOTOGRAPHS

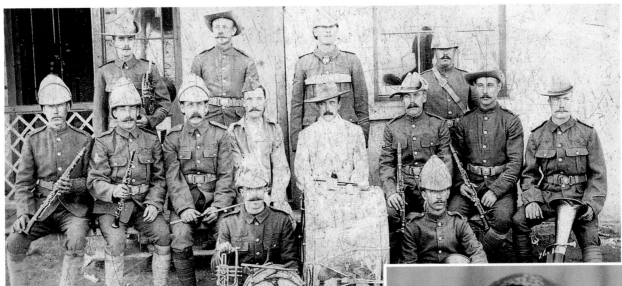

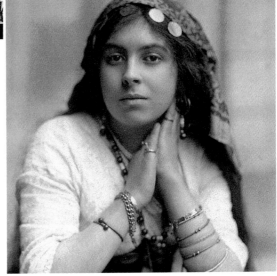

The first photographic cameras were very similar to a camera obscura, but with the inverted image reflected onto a photo-sensitive glass plate on the back wall of the device. Initially, the exposure was made by removing the lens cap for the required exposure time – often a few minutes – and then replacing it. As the sensitivity of film improved and exposure times shortened, a timed shutter was added to give accurate results.

Such was the demand for this wonderful new invention that before long more sophisticated cameras were developed that could be used outside as well as in the studio.

Early photographs of towns seem mysteriously devoid of people, but this doesn't mean there weren't any. Because of the long exposure times, unless they stood still throughout most of the exposure time, they would not be recorded at all. Some appeared as ghostly images, and others as merely unrecognisable smudges.

In early portrait photography, clamps were arranged out of sight to hold sitters' heads perfectly still so the image was sharp, and sometimes the light was improved by igniting magnesium in a tray.

The armed forces were quick to use the camera to record their activities. For the first time, the real horror of war could be seen. Images of the corpses and the suffering of the soldiers taken during the Crimean and American Civil Wars have a similar resonance to those taken in modern wars – very different from the gung-ho, romanticized battle scenes portrayed in the paintings of Denis Dighton or Baron Lejeune. The photograph of the military band (above) was taken in 1900 during the Boer War. My grandfather is third from the right in the centre row.

Prior to the invention of photography, the only way to have a portrait done was to employ an artist – an expensive option not open to all. By the late 1880s, commercial photographers were becoming established in the high street and competition was keeping prices down. The portrait of the young woman (above) was of a friend of my grandmother's, who later explained how it came about. At the time the photograph was taken, around 1907, my grandmother and many of her friends were in service in London. On their days off they would go out together. On one occasion they all planned to go to a fancy dress ball and so begged, borrowed or hired outfits. On their way, they passed a photographer's studio and several of the girls decided to have their photos taken. Elsie, the girl dressed as a gypsy, was one of these. My grandmother, a close friend, was given this copy.

ARTISTS USING PHOTOGRAPHS

When photography began to become popular, many artists gloomily saw this as the end of painting as an art form. Both portrait and landscape painters felt especially threatened by this new medium. Some artists abandoned oils and canvas and went into photography, and many of the early photographs were staged to imitate paintings.

While many painters rejected photography outright, many saw it as a great opportunity, not just as a medium in itself, but as a valuable tool that could both reduce the costs (models hired by the hour could be expensive and were often unreliable and prone to fainting during long poses) and ease the work practices (the light doesn't keep changing in a photograph, which allows you to work day or night should you wish to).

ABOVE A studio set-up for the painting
In the Midst of Life we are in Death, 1894; Caroline Gotch
Courtesy of Alan Shears Fine Art

Photography also allowed the artist to try out compositions. The studio set-up shown was arranged in 1894 by Caroline Gotch of the Newlyn school as a study for her painting "In the Midst of Life we are in Death". Many of the Impressionists and Pre-Raphaelites are also known to have used photographs in lieu of drawings to work from. The painting "Work" by Ford Madox Brown was based entirely on several photographs.

EARLY CAMERAS – PHOTOGRAPHY TECHNIQUES

Professional photographers often had a range of cameras in their studios, but all required the use of a heavy tripod to ensure sharp results. The size of the camera reflected the size of the negative that could be used, and thus the size of the prints that could be made. The camera shown on the right is an Isa folding plate camera, which used a 2½ x 3½-inch glass-plate film. The photo of the lady with a dog (far right) is typical of a studio photograph of about 1907. The setting is 'stagey' and attempts to imitate the style of an oil painting.

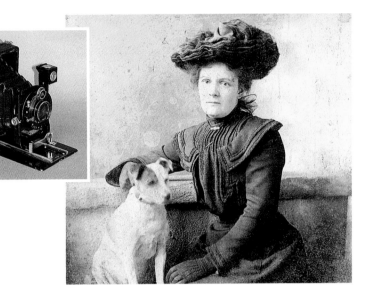

The introduction of roll film brought a revolution in camera design. The Kodak Box Brownie camera of 1900 shown below right, was the first mass-produced camera. It was cheap, effective and brought photography to the masses. The camera was simple, with a fixed focus, aperture and shutter speed. Users tended to follow simple rules, such as always having the sun behind them, to ensure successful photographs. Box Brownie cameras of various types were still in production in the early 1940s. The one illustrated is a Six-20 Popular, introduced in 1939. The landscape shown was taken with this camera.

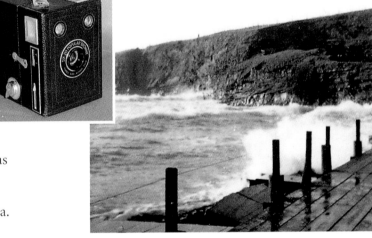

The desire for a smaller, more flexible type of camera, the 35-mm camera (below right), was realized in Germany in 1924 by Oskar Barnack. The camera, which utilized 35-mm cine film, was manufactured by E. Leitz of Wetzlar and named Leica. The high-quality lens, and the ability to focus and adjust the shutter speed and aperture, compensated for the small size of the negative – about a quarter of the size of the Box Brownie's. This small size had other benefits – instead of films of eight or 12 exposures, these cameras could hold films of 24 or 36 exposures. This type of camera could be used almost anywhere and, because the aperture, shutter speed and focusing were controllable, photographs could be taken in most lights, especially if flashbulbs, developed in the 1930s, were used.

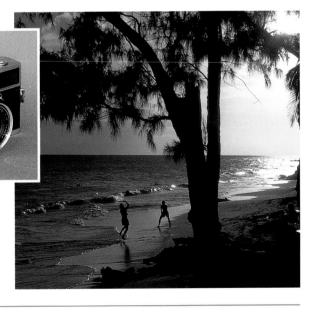

Before long, 35-mm cameras were in use by professional and serious amateur photographers. The camera shown above is an Olympus 35 SP 35-mm rangefinder of the 1970s. The photograph was taken with a Yashica Minister D 35-mm camera.

MODERN CAMERAS

Point-and-shoot cameras developed from the Brownie type into a range of simple cameras. Following liaisons with various negative sizes, most camera manufacturers settled for the 35-mm type, simply because the popularity of this film and its ease of processing were suited to the perceived domestic market for the cameras.

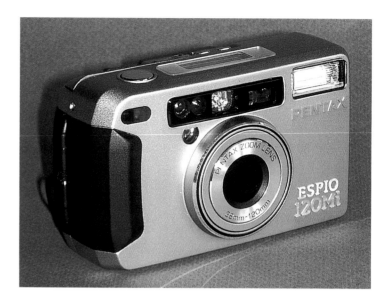

Automated flash, exposure and focusing became available in the more expensive types, and nowadays these facilities come as standard and are incorporated into all but the cheapest models. The camera shown on the right is a Pentax Espio 120Mi, which is fully automated and has a zoom lens.

It was realized that with 35-mm viewfinder cameras the user didn't see exactly what the lens saw. This could pose problems so, in the late 1920s, the German manufacturer Ihagee Exakta manufactured the first 35-mm single-lens reflex camera. The user looks through a prism mounted on the top of the camera and, via an angled mirror, can see directly through the camera lens. At the point of taking the photograph, the mirror flips up out of the way and the shutter operates. The great advantage is that different lenses can be interchanged at will, without making any other additions, giving the camera great versatility. The camera shown on the right is my battered old 1984 Olympus OM-2 SP.

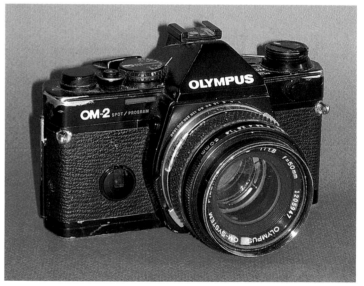

The age of the computer has given us the digital camera, which, as the name suggests, does not use film. Instead, the image is recorded by a CCD sensor and rated in terms of the number of millions of pixels contained within the device.

The images taken are stored on special memory cards, which can then be removed from the camera, the pictures processed through a computer and prints made. Large-capacity cards can hold more than a hundred images and, if desired, these can be transferred onto a CD-ROM or DVD, and the card erased for re-use. Being computer generated, the images can be manipulated using software programmes such as Photoshop, or Paint Shop Pro. Most digital cameras incorporate a small screen that enables the user to check the images that he or she has taken.

The digital reflex camera on the right is my five million pixel Olympus E20P. Many of the photographs in this book were taken with this camera.

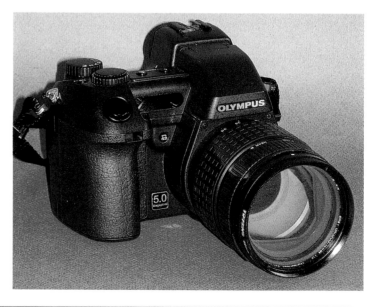

PART TWO
USING PHOTOGRAPHS
AS REFERENCES

PHOTOGRAPHS – AS PHOTOGRAPHS

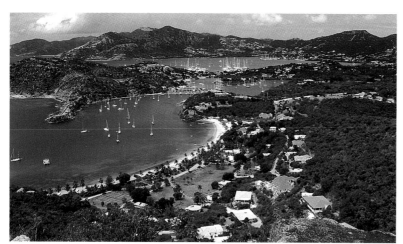

LEFT English Harbour from Shirley Heights, Antigua;
Photo by Tony Paul

BELOW The Seafront, Lyme Regis;
Photo by Tony Paul

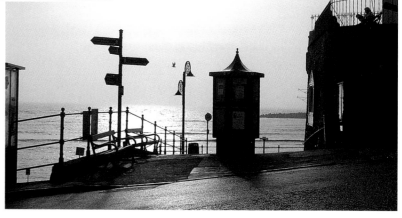

Landscapes

The top photograph is of the view over English Harbour in Antigua, which I took from Shirley Heights. The photo is sharp, the colour good and the composition sound, with the eye being led around the curve of the beach to the focal area where the square-rigged ship and the other boats are berthed. As a memory of a good holiday and a topographical view of this part of the island it succeeds, but it is unlikely to make a successful painting, because painting is about atmosphere and simplification. In this photo, there is little or no atmosphere and too much fiddly detail. Simplifying, while retaining a centre of interest, would be difficult.

Unlike the photo of Antigua, the photo of Lyme Regis has plenty of atmosphere, but is very sparse on information, much of the image consisting of impenetrable dark shapes. The colours are very limited and, without putting information into the darks, I don't feel that it would be successful as a painting.

The sharpness and clarity of Ian Aston's digital photo of Les Halles in Paris is remarkable. I like the repetition of the inverted 'J' shapes that run through the picture, the colour and the children on their bikes, which give scale and human interest, and the contrast between modern and traditional architecture in the new buildings and the church. It is a great photograph, but far too busy to be a painting.

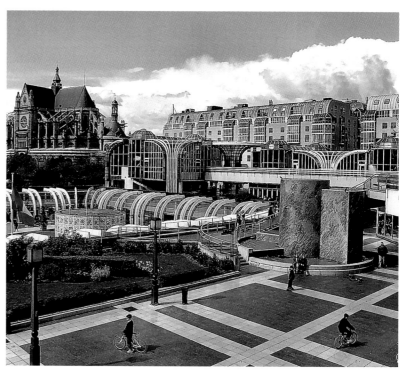

ABOVE Les Halles, Paris;
Photo by Ian Aston

Portraits

There is absolutely nothing wrong with the school photograph illustrated on the right. It was well taken, the lighting is good and the girls' expressions happy. It would be relatively easy to paint a picture from this photo thanks to the modelling on the faces, but I really don't think it would work as well as a painting as it does as a photograph. Somehow, broad toothy grins don't translate well into paintings.

The same can be said of the family photo, below right. The lady (my wife) is smiling, daughter Julie is laughing, and even Sherry the dog appears to be chuckling. Attractive as they all are, a painting of all this sunshine and jollity is better left as a photograph for the same reasons mentioned above. They are wonderful reminders for the family album and are best left as that.

I took the photo, below, of Lynsey on her fifth birthday party and, although I would not want to work a painting from it, it does have more to it than just a shot of happily grinning people looking into the camera. It is a moment of expectation caught. All eyes are on the cake, intent on seeing the candles blown out. Lyn has a determined look, having breathed deeply so she could blow the candles out in one breath. Norman Rockwell would have made a wonderful painting based on this, but for me it still works best as a photo from the album.

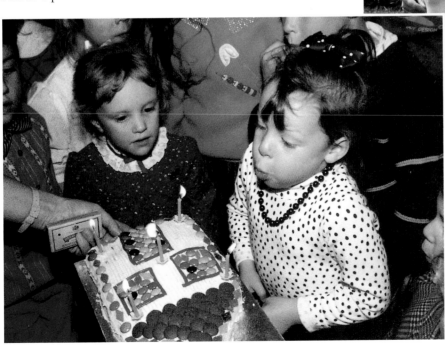

PHOTOGRAPHS FOR PAINTING

Landscapes

Landscape photographs that merely report the landscape, as on page 18, are rarely successful as paintings. Ones taken with the idea of making a painting should have certain characteristics: they need to have shapes that allow the eye to move on a journey through the image; they must have an evocative quality of light and strong forms; the colours do not have to be bright, but should sit together well; and they should inspire a painterly approach. Any painting made from a photo that relies on intricate detail for its effect will almost certainly be doomed to failure.

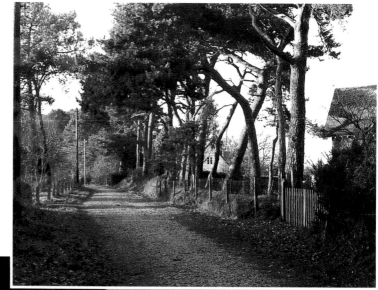

The composition of a painting is vital. In times past, the composition of a painting would be worked out almost mathematically in terms of a series of geometric shapes, or perhaps based on the 'golden section'. Nowadays, there is little need for such formal structuring.

Many compositions are based around letter forms: Talbot Woods (above) is a classic 'x' form painting as used by Hobbema and Pissarro, the strong perspective lines from above and below cross and give a great feeling of depth. The verticals of the tree trunks and the horizontals of the shadows on the path slow the eye's progress down the lane, making the journey more enjoyable. A human, or even canine, element added somewhere in the distance would help give both a sense of scale and a focal point.

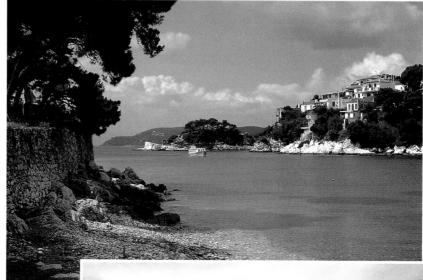

The photo of Skiathos (middle) is a composition based on a 'c' shape. The overhang of the trees on the left and the curve of the shore below create a 'c'. The landscape on the other side of the harbour entrance sits within and echoes this shape, albeit in a more flattened form.

The Gatehouse, Portchester Castle (right) is based on a wedge-shaped composition, wide on the right and narrowed on the left. The shapes are strong and there is plenty of interest to lead the eye to the centre of interest: the gatehouse itself. Although not brightly sunlit, there is sufficient light to model the structure of the buildings, and the seated sketcher gives these a sense of scale.

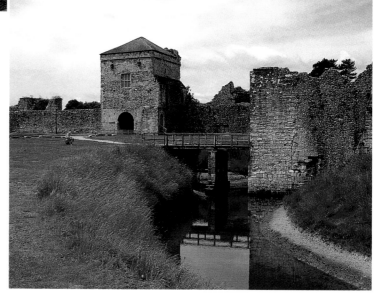

Portraits

Portraits of babies can look awful. Often they can look bloated, fat cheeked and piggy eyed. They rarely make good paintings. But look at the black and white photograph on the right, of my wife, Rae, with our first daughter, Sally. Taken in black and white, the proud new mother holds her baby. The light on the subject is soft, coming from the right and diffused by a net curtain.

The fact that we can see little of the mother's face behind the curtain of her hair adds a touch of intimacy to the subject. In a way, this mother has now become anonymous, perhaps a symbol for motherhood. Baby Sally doesn't look bloated, as the light gently defines the forms of her head and clothing. I painted an oil from this photograph.

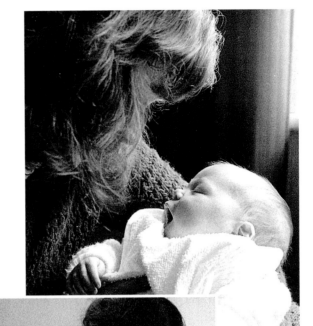

My fourth daughter, Lynsey, has the most beautiful creamy complexion, typical of a redhead. As you can see from the photograph on the right, I posed her in the light coming through a window, making sure that there was enough shadow to softly model her head. The pose is natural, she doesn't look at us but appears pensive, lost in her own thoughts. The head resting in her hand is a good ploy – she looks relaxed, and hiding the hand behind the head provides interest without creating the difficulty of painting it. I like the glint of light reflected from her eye and the slightly untidy bun of hair.

The photo on the right is of a friend of mine, Rod. Like the photo of Lynsey, it, too, is a profile, taken indoors using only natural light. In this photo, I have caught something of Rod's personality. There are hints of his humour, determination and ambition, and the fact that he doesn't look at us tells us that he has a private side, too. The modelling on the face and hair is clear, the front of his face is light against dark, and the back of his head dark against a lighter background.

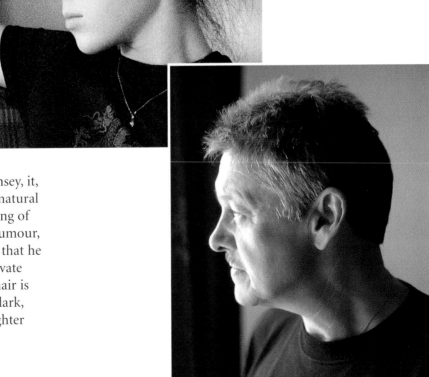

PHOTOGRAPHS — SUITABLE AND UNSUITABLE

Landscapes

This photograph of the almshouses in Castle Rising in Norfolk, was taken in dull light. See how the trees all blend into one mass of much the same tone and colour, and although the almshouses themselves are a different colour to the trees, tonally they are similar. If you look through your eyelashes at the photo you will see that the almshouses are almost lost against their background of trees. The general effect of a painting based on this shot would be of dullness, and a lot of 'beefing up' would be needed to make it effective.

X

The presence of the sun has transformed the scene. Darks punctuate the row of trees on the left to centre, separating them and giving us a sense of depth, and the greens soften as they recede. Strong shadows are cast over the wall and road, defining their contours, and the almshouses come to life with the contrasts of light and shadow, giving form to the walls, roofs and chimneys. If the cars bother you, walk past them and take another shot of what lies beyond, and use both references for the painting.

✓

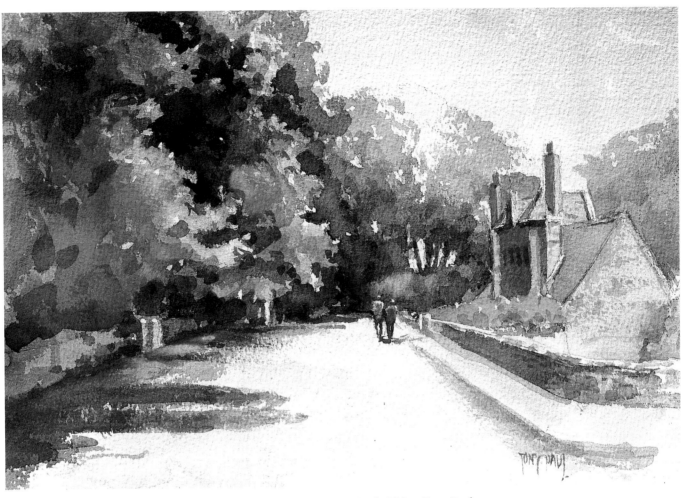

ABOVE The Almshouses at Castle Rising; Tony Paul
Watercolour, 280 x 380 mm (11 x 15 in)

I wanted my painting, "The Almshouses at Castle Rising", to have the fresh character of a watercolour painted in front of the subject. Unfortunately, the time that working from a photo allows can encourage too much fiddling. I was determined not to fall into that trap.

I felt that the overall greenness of the subject required that I should put more colour in, so I decided to break the range of the left-hand trees with a tree with brownish foliage.

Beginning with a tonal underpainting, I added grey greens to the distant trees, allowing the brushstrokes to break up to give an interesting edge to the trees. The plunging darks below the trees now went in using a dark grey green. The light-coloured foliage of the brown tree was a good foil against the dark trees behind, pulling it forward from the background. The deep brown shade of this tree was again counterpointed with a nearer tree of a brighter green.

I crossed the road and worked on the almshouses, keeping their forms simple, but making sure that they read well against the background. The fresher greens of the hedge in the almshouses and the grass by the wall on the opposite side of the road add a hint of acid colour to counter the warm coloration elsewhere in the painting. I left out the cars and added two figures in their place to give scale.

You will see from this painting that I have not copied the lower photo on the previous page. I used it as a source of information as I would have done with a sketch. I haven't felt that I needed to be too constrained by the photo's colours or details. I have made it an interpretation of the subject.

Beach huts

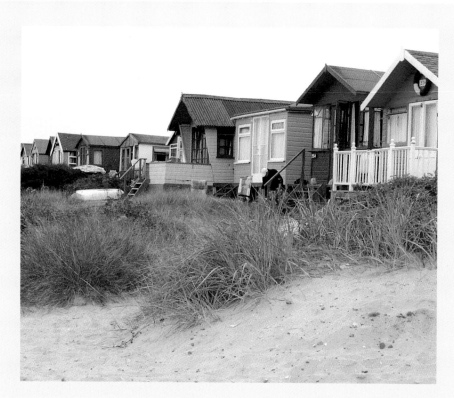

Marita saw this subject one dull summer's day and liked the contrasting colours of the huts. Despite the poor light, the weather was warm and the huts were in use, so she could see the configuration of the doors and windows.

The seaside, and beach huts in particular, are all about sunny subjects but nevertheless she took this photo. The lack of sun made the subject a little bland. It wouldn't have made a good painting.

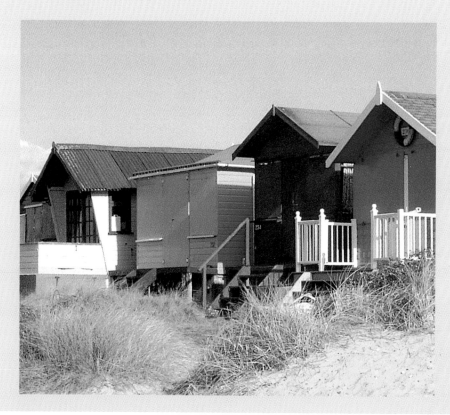

Marita had the film processed and liked the subject, so a few months later, on a cold but sunny February morning, she returned and took this photograph. The bright sun gave form, colour and good shadows but, of course, it being winter, the beach huts' security shutters were locked. She had the information about the doors and windows from the earlier photo and so began to paint.

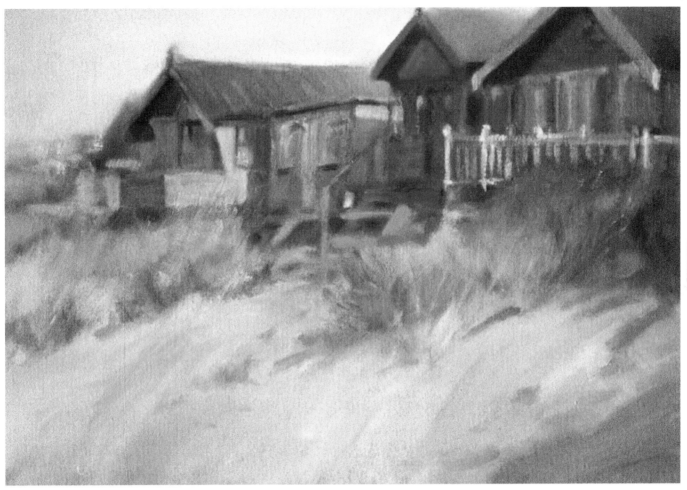

ABOVE Mudeford Beach Huts; Marita Freeman
Pastel, 380 x 560 mm (15 x 22 in)

Using the two photographs as references, Marita worked the subject into this painting. The most important aspect of using your own photographs is that you were there. The photo acts as an aide-mémoire. You remember the heat of the day, the sound of the sea and gulls, the feel of the sand between your toes – you relive the whole experience.

Marita used the photos in the same way that she would have used a drawing, recreating the shapes and forms of the huts. But photographs do not tell the truth. The day of the first photograph was hot – it doesn't look hot. The second photograph looks sunny, but it was cold. Neither photo expresses the experience of being on a sunny beach in the height of summer. It took Marita's memory of what it was really like to put a sense of a hot day at the beach into the painting.

See how she has used warmer colours. The cold blue of the sunny photo's sky has been replaced with a warm beige, and the sand has hot pinks and oranges. All the colours on the huts have been made warm, too, and the gently diffused painting technique has the look of a painting made on the spot. There isn't any attempt to literally copy the photographs. She has used them solely for the useful information they contain.

COMMISSIONS BASED ON PHOTOGRAPHS

Portraits

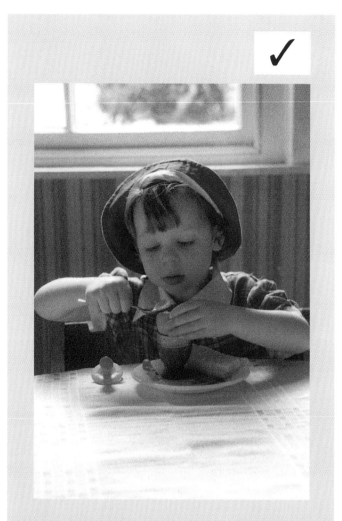

The most common commissions offered to the artist are portraits. The photograph above is typical of the kind of image that the client will give you to work from. This one is a photographer's studio photo of my daughter Lynsey, taken when she was five or six. There's nothing wrong with it, except that it will make rather a bland painting. We all have photos of our children like this – dressed in their best clothes, neatly groomed and smiling for the camera. Even if well executed, a painting made from this will probably look like little more than a copy of a photo, and will ultimately prove to be disappointing.

If you can, suggest to the commissioner that you take some photos of the sitter, perhaps in everyday dress, doing something he or she enjoys. Ultimately it will make a more interesting image, revealing more of the subject's personality.

The photograph above is technically inferior to the professional's studio shot, yet somehow it has captured something of Lyn's personality. The jaunty hat, the figure against the natural light of the window and the breakfast egg all make the portrait more revealing and more of a subject.

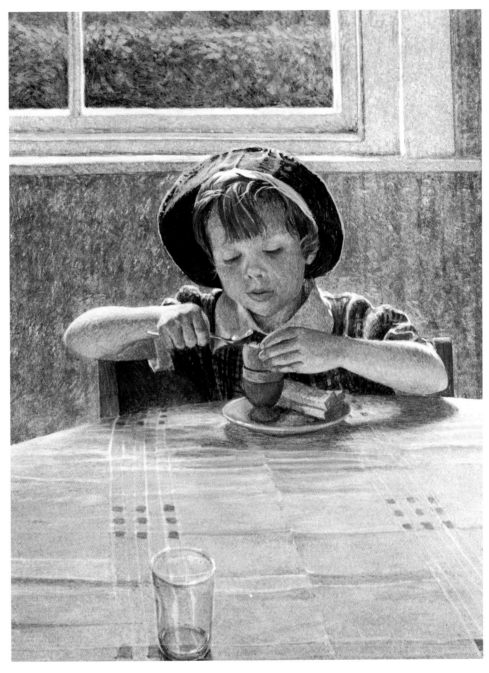

ABOVE The Breakfast Egg; Tony Paul
Egg Tempera, 305 x 254 mm (12 x 10 in)

You will see from the resulting egg tempera painting that I have used the photo as a basis for the portrait. But I didn't just copy it. I have both added and taken away elements and adjusted things. For instance: I have lengthened the table slightly, added a glass on its near edge and left out the comforter. I have taken the very slight effect of reflected light from the photo and exaggerated it, giving a greater feeling of modelling to the face and sharpening the features. I also felt that the whitish wall outside the window drew the eye away from the figure and the rather ragged hedge was unhelpful, so I imagined a much lower hedge, tidied it up and implied a garden beyond. I had to take the pose, the general lighting and the figure fairly literally, or it wouldn't have looked like Lyn, but where I could I made the colours a little livelier to reduce the Kodacolour effect.

Dog portraits

Sometimes the owner of a dog will offer you photos such as this to work from. Unfortunately, it contains several faults: it is rarely satisfactory to look down on a dog. He looks threatened, and the red eye that the camera's flash has given him has made him look aggressive, too. The dog is in two different lights – partly in strong sun and partly in the shade. The camera has not coped with either very well, bleaching out the sunlit bits and leaving the shaded areas almost solid black. To make a decent painting from such a photo would be almost impossible. If you were asked to work from a photo such as this, it would be best to tactfully say that you would prefer to take your own.

If the dog has died, you should ask to see a range of other photographs of the animal and perhaps combine the information in those to make the painting.

X

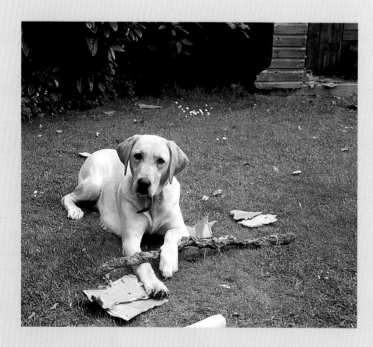

I lay down and propped myself up on my elbows to take this photo of Molly. It is important to view dogs from their level. If you are to photograph a dog for a commission, get down to its level as soon as you can. At first it may think that you want to play or may feel wary, but soon it will be bored with your antics and will allow you to photograph it in a characteristic pose.

Make sure the light is helping to describe its form and be particularly careful with black dogs. If the modelling of its form is not crystal clear, it would be best to bracket the exposure (see p 32) and avoid bright backgrounds, which the camera would adjust to, leaving the dog as an impenetrable black silhouette.

A typically destructive Labrador, Molly loved nothing better than to tear up cardboard boxes and chew sticks. She is in a good light that describes her form well, and the relatively plain background is not distracting.

✓

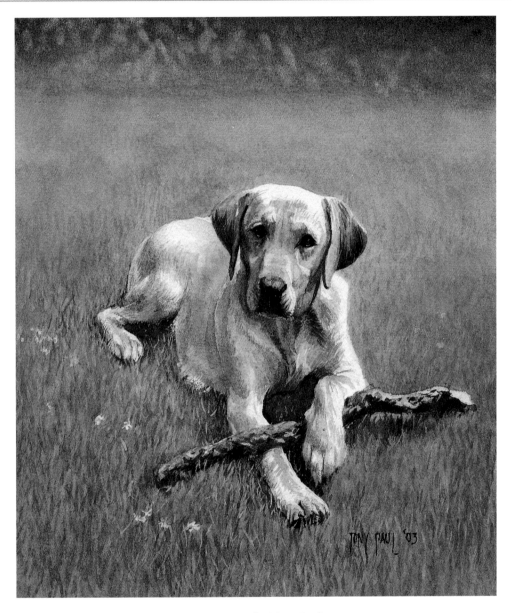

ABOVE Molly; Tony Paul
Watercolour, 184 x 140 mm (7¼ x 5½ in)

I decided to leave out the Wendy house and torn-up cardboard box to give a tidier painting. My first task was to wash over the background with green. I made it slightly stronger in the foreground and weaker in the background to reinforce the feeling of recession. I aimed to make it as close to the finished tone as I could so that I could then relate Molly's tones and colours to it.

Starting on the dog, I began by applying the palest areas of her coat, afterwards putting in the strongest shadows. I exaggerated the strength of the darks slightly to make the modelling more pronounced. I then filled in the other tones, comparing them to both the darks and lights already painted. For this, I used a fairly small round brush, applying fine lines in the direction of the fur.

Having finished work on Molly, the grass looked very flat – almost like green baize – so I then worked over it, first applying darker strokes, longer in the foreground, then fading to nothing in the background. This all looked slightly too fresh and green, so I mixed some raw sienna with varying amounts of white gouache and added more modelling to it. Finally, I put in a few daisies with white gouache and a touch of yellow. Although there is a fair amount of detail in the painting, it still has the look of a painting, rather than a photograph, the brushwork and the overlaid washes being quite evident.

TAKING YOUR OWN PHOTOGRAPHS

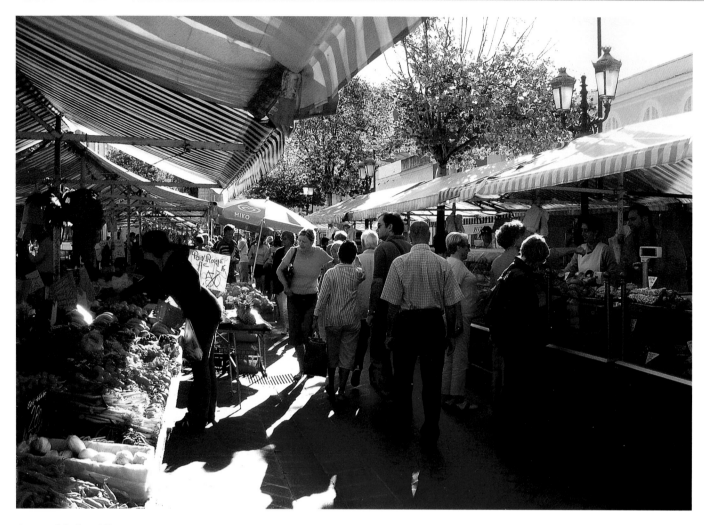

ABOVE Market, Nice
Photo by Tony Paul

When looking for subjects, the photographer often has to think quickly and try to consider many things at once. This is especially true of busy scenes such as this market in Nice. As the light was more or less streaming into the camera lens, I ducked under an awning to avoid flare fogging the shot. I liked the stripes of the awnings, the colour and the effects of light and dark, and of course the figures, which bring the whole thing to life. I focused carefully. The light was bright, so I knew that the shutter speed would be sufficiently fast to avoid blurring, and the depth of field deep enough so that most of the image would be sharp. Using a digital camera helped, as the depth of field is greater than with film cameras.

When I first raised the camera, there were several people in the immediate foreground, both coming towards me and going away. This would have been too oppressive. They would have dominated the painting and masked much of the interest in the stalls, so I waited until there was an area of clear footpath in the foreground before taking the shot. Sometimes you can be lucky, and on this occasion I was. The lady in the pink top is a perfect focal point, the colour being an ideal foil to the many cool neutrals around her. I also liked the halo of light around her head.

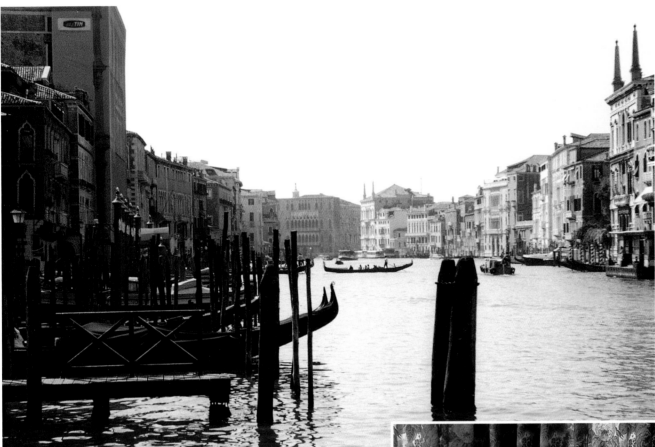

ABOVE Grand Canal, Venice
Photo by Tony Paul

This photo of the Grand Canal, Venice, has some good elements. I like the repetitive poles and the landing stage in the left foreground, which partially veil the shadowed sides of the buildings behind them. The opposite side has buildings in sunlight, but also with shadowed areas that give them form. I don't like the way that the tops of the double poles, standing on their own in the centre right foreground, coincide with the edge of the canal. I would make it lower or higher; it matters little. On the other hand, they are quite a dominant shapes so I might well leave them out altogether, or replace them with a thinner, less heavy pole.

The photo of Julie was taken in natural light. I closed one of the pair of curtains. This has given interesting lighting. The light of her face contrasts with the darker curtain, while the dark of her hair is framed by the lighter area of curtain. The colours are very rich and warm, and the light models her form well. Her pose was arranged but looks natural, and the inclusion of the whole figure makes it as much a figure study as a portrait.

ABOVE Julie
Photo by Tony Paul

HIGH-CONTRAST SUBJECTS

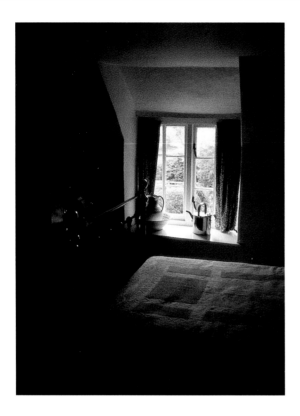
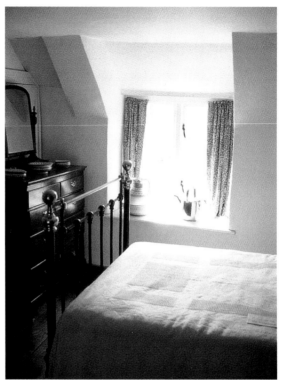

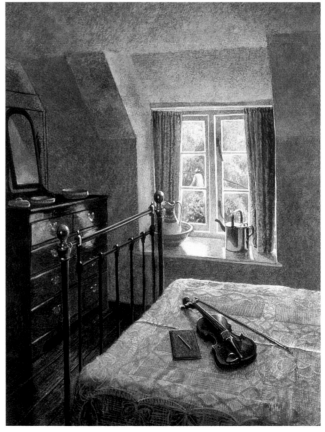

Photographic film cannot cope with subjects with strong tonal contrasts, such as bright lights and deep darks. If you wish to paint a picture that has these strong contrasts, the best solution is to take at least two shots of the subject – this is known as 'bracketing' by photographers – exposing for the various lights and darks. You should switch off the camera's flash (if fitted) and will probably need to use a tripod to avoid a blurred image caused by camera shake, as the darks will need a longer exposure.

With most modern cameras with automatic exposure, there will be an 'exposure lock' facility (consult your camera manual for further information). This allows you to point at a particular part of the subject and lock the exposure, upon which you then reframe to the whole of the subject and take the shot. The resulting photo will then have a tonal range based on your selected area.

The two photos above were references for the painting of the bedroom in Thomas Hardy's cottage in Dorset. I decided to take two shots: the first one for the lighter tones of the window area and outside – in this case the detail in the darks would be lost; and the second for the darks – where the light areas would be bleached out. This gave me all the information that I needed to paint the picture to the right.

ABOVE Hardy's Cottage; Tony Paul
Egg Tempera, 356 x 254 mm (14 x 10 in)

COPYING – THE LEGALITIES

There is no reason why you can't copy from any reference. Before the 19th century, copying the work of another artist was considered to be important in the development of any painter, and there were many masters who approved of the practice. William Blake stated: 'The difference between a bad artist and a good one is that a bad artist *seems* to copy a great deal. The good one *really does* copy a great deal.' And Salvador Dali said: 'Those who do not want to imitate anything, produce nothing.'

With the aim of learning painting technique, copying is still a valuable way of educating yourself. If you go to a national gallery anywhere in the world, you will see artists copying work and groups of children squatting in front of a work, scribbling away. The galleries positively encourage involvement with art through their collections. But it is what you do with that copy that could land you in trouble. If you take your copy and try to sell it as the work of the master, you will be committing the criminal act of fraud. If you try to make money from it by selling or reproducing it, you could be in breach of copyright. This is why, in most art galleries, you have to sign to the effect that the copy you make will be for study, rather than for commercial purposes.

When you paint a picture, it is automatically under copyright. Good or bad, no one has the right to use your painting without your permission. If they do, they are in breach of copyright. That copyright will be in force from the day of completion of the work to 70 years beyond the end of the year in which you die. You enjoy the benefits and protection of copyright straightaway.

Copyright also works for others, too, so copying or taking bits willy-nilly from other people's works, be they painted, written, played on an instrument or photographed, will probably be an infringement if you try to sell the painting, unless the copyright has expired – i.e. more than 70 years after the creator of the work's death.

In one of my columns for *Leisure Painter*, I invited readers to send in paintings on a particular subject. When several were printed in the magazine, the editor was deluged with letters telling her that two of the published paintings were direct copies – one of a photograph that had appeared in a national newspaper, the other of a painting in an art techniques book. If the copyright owners had found out, the copiers could have been sued. The magazine now asks readers who submit paintings for publication to sign an agreement stating that should a copyright issue arise, they will take responsibility for any costs arising.

I have already said that it is best (and safest) to work from your own photographs, because they were taken while you were there and so act as much as aide-mémoires as they do references.

If you are desperate to sell a painting derived from a published image, you can always contact the owner of the copyright and ask him/her what the fee would be. You may be lucky and he/she may allow you to use it without charge, but get this in writing.

If you need to use historical photographs or shots of personalities or incidents, try to get as many different views as you can and absorb the information they give. Do a sketch that could not be identified as a copy of any one reference.

Copyright is a complicated minefield, and the artist is well advised to tread carefully in his use of references. Ignoring the law could prove a stressful and costly mistake.

PART THREE
ADAPTING THE IMAGE

CROPPING

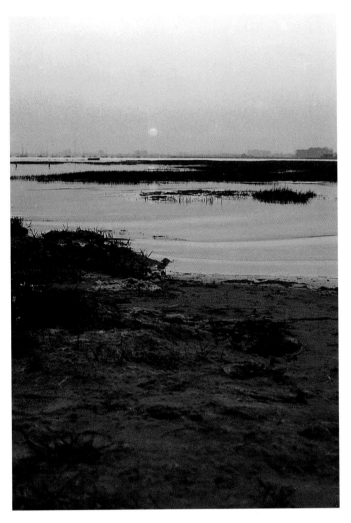

Some photographs that have been taken without much consideration for composition, or which may well work as photographs but not so well as a basis for a painting, can benefit from cropping – that is to say using only part of the image.

When working in front of the subject, we make judgements about what we want to include in the painting. Usually this works, but sometimes we are well into the painting before we realise that the painting is out of balance, or shows too much or too little of the subject.

An advantage of working from a photograph is that you do get the opportunity to try out different, reduced compositions. Four slips of paper can be used to mask off the unwanted area and improve the balance and content of the composition.

I wanted to paint a watercolour of the sunset of Poole Harbour, based on the photo at the top of the page. I wished to capture the tranquillity of the evening light and the soft quality of the colours. Looking at it, I thought that the mudflat, which covers almost all the bottom half of the photo, while it looked fine in the photograph, took up too much of the image and detracted from the real subject of the painting, which is, of course, the sunset.

I tried reducing the size of the image by degrees and eventually got rid of the mudflats entirely, cutting the subject off just below the salt-marsh 'island'. This made the sky look too deep, so when I lowered this I felt that the subject was horizontally too wide for its depth.

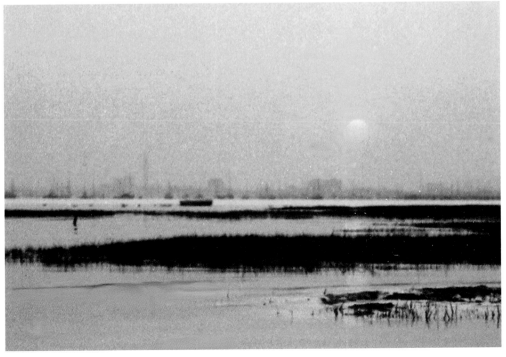

I didn't want the setting sun to be centrally placed, so I decided to crop a fair piece off from the right. I felt this made the image more sympathetic to multi-washes in watercolour.

ABOVE AND LEFT Sunset, Poole Harbour;
Photo by Tony Paul

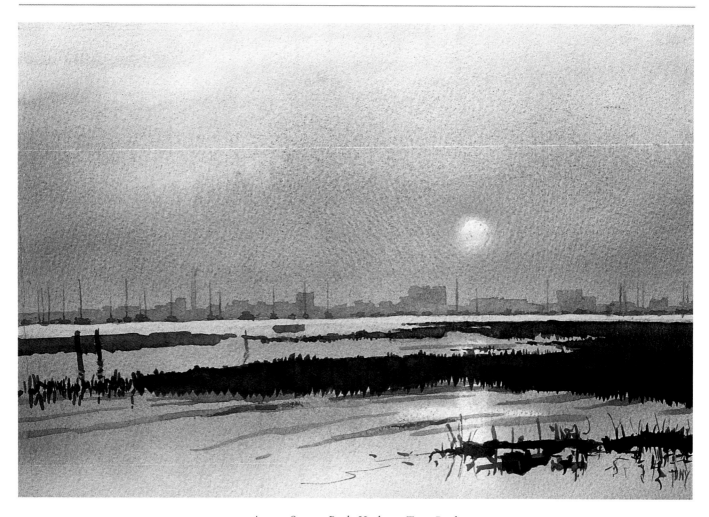

ABOVE Sunset, Poole Harbour; Tony Paul
Watercolour, 279 x 381 mm (11 x 15 in)

It is often said that watercolour painting is 90 per cent contemplation and 10 per cent perspiration, and this is largely true. It would have been impossible to mix the colours of this sunset and apply them in one wash, so I had to look hard at the photo to divide the colour into separate washes.

I came to the conclusion that this subject needed three main washes, but first I masked out the setting sun and its reflections with masking fluid. The first colour I applied was an overall flat wash of pale orange, which set the underglow. When this was dry, it was followed by a second wash of permanent rose, strongest at the horizon area and gradating to paler tones at both the top and bottom of the painting.

Overlaying this would be a final wash of ultramarine, which I would paint in two parts, leaving a strip unpainted. The first part – strongest at the line of the top edge of the far salt marsh – was made paler as it went down the paper. I then turned the paper upside down and painted a similar gradated wash with its top along the waterline, softening as it came away from the central area of the painting. This left a clear lane of water unpainted with the blue.

After drying, the painting was turned right way up and the line of distant buildings put in with a smaller brush, using the residue of blue paint.

A dark mix of burnt umber and ultramarine was used to put in the saltmarshes. The colour was dark yet fluid and applied wetly so that it went on without streaking.

The painting was then almost complete, only needing the tiny distant boats and the near ripples on the water to be added. The final touch was to remove the masking fluid. Immediately, the white of the sun and its reflections appeard far too luminous, so the revealed paper was softened by putting in some permanent rose, making sure that it remained paler than any of the other tones of the painting – the source of light, by the laws of nature, will always be the lightest tone in the painting.

USING MORE THAN ONE PHOTOGRAPH

Cliffs at West Bay;
Photos by Tony Paul

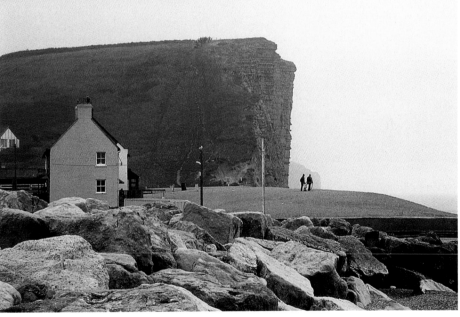

I took the first photograph of the beach and cliffs of the Dorset fishing village of West Bay one summer morning. The bright sun had created a thin haze, which softened the forms of the pink house and the cliffs beyond.

I liked the effect of light immensely, and felt that it would make an ideal subject for a painting, the whole landscape having a warm glow. There were many different textures and layers in the painting: in the foreground, the rocks and behind them, the quay walls that create a channel that reaches out into the sea. The tones soften in the middle distance with the pink house, which, because it is contre-jour, didn't stand out as strongly as it does in other lights.

The steep cliff that looms over the house and pebble beach was softer again, veiled by a soft purplish haze, and beyond this the distant cliffs were almost indiscernible.

In contrast, the second photograph, taken on another occasion, has none of the atmosphere of the first. The scene is bathed in an afternoon light, which has little of the drama and character of the first photo. But what the second photo has is the two figures, who are walking on the mound of the pebbly beach. Immediately, the scale changes. What initially appeared as a simple, pink fisherman's cottage, we now realize is a much larger building (three storeys in fact), and the tiny size of the figures by contrast shows just how high the cliffs are. Often seascape paintings can look desolate if devoid of people, so it really helped to have these two people to put in.

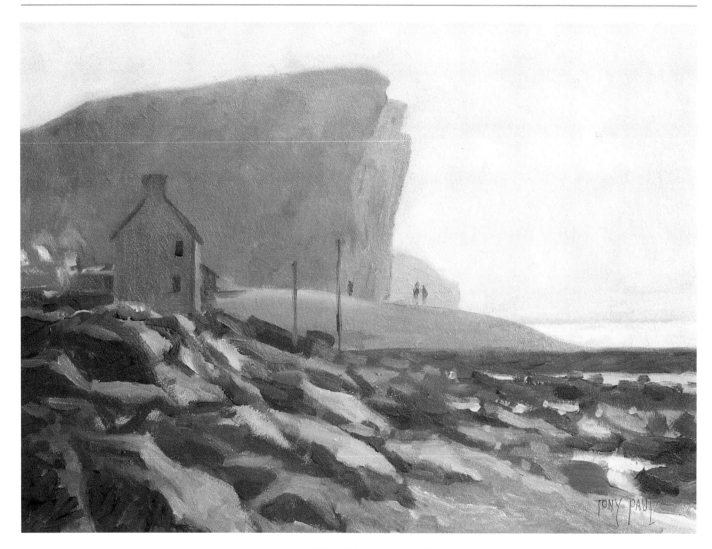

ABOVE Cliff at West Bay; Tony Paul
Oil, 241 x 292 mm (9½ x 11½ in)

I felt that oil would be the best medium to convey the character of the subject and decided to use the water-mixable type, with a rough acrylic-primed MDF panel as a support.

I began by painting the sky, using a loose blend of blue and Naples yellow with a touch of cadmium red strongly lightened with white. The distant cliff was of a dull purple made from ultramarine and cadmium red, reduced with white.

I had to be careful to get the light right on the main cliff – the face was receiving raking light, while the flank facing me was in shadow. I used an orange made from Naples yellow and cadmium red with white for the face, cooled with viridian here and there. A slightly darker mix of these colours was used for the shaded side of the cliff. I also painted the gable end of the pink house in this colour, letting its lighter front elevation and the dark line of the roof pull it away from the cliff.

Naples yellow and cadmium red, cooled with a touch of blue, captured the beach. The darks that define the rocks were a blend of ultramarine and Indian red, the lights being a similar mix but loaded with white. The tiny figures were suggested simply with dark paint applied with a small synthetic brush.

With this painting, my aim was to produce a work that had the look of a spontaneous sketch. I kept the colours fresh and the application loose and lively. There was no attempt to reproduce the detail in the photographs.

ADDING IN ELEMENTS – BEWARE OF PERSPECTIVE

Buildings

When adding buildings into a painting, or other elements into a painting that include buildings, it is important that they blend seamlessly together. The best way of working is to ensure that the eye level of the viewer is consistent both in the original reference photo and in the photo from which you want to take elements.

When taking photos that you later might wish to work up into paintings, it is best to take the photos from a standing position at ground level. This will ensure that your photos have a consistent eye level. If we look at the photo of the Alhambra Palace (top right), the courtyard is flat and level. The eye level is shown by the line. You can see that my head level was broadly similar to those of other tourists and that lines going away from me, such as the edges of the water feature, rise towards the eye level as they recede, whereas those above my eye level, such as the roof edges, go down towards the eye level as they recede. Any other elements that I bring into the painting will have to conform to this same eye level or they will look odd or foreign.

In the photo of the Spanish village (right) I am standing at the top of a steeply sloping hill – so I have a high viewpoint. In this case, my eye level is up by the roofs of nearby houses. You can quite clearly see that almost all the lines within the subject are below my eye level because they slope up to the eye level as they recede. The further below my eye level the lines are, the steeper the recession. Again, any elements that I wish to add will have to have a similar viewpoint.

The view of Philipps House (right) is very different. It stands on a knoll and its classical facade is all the more impressive because we are looking up at it. See that all the lines within the building that recede away slope downwards as they go – a sure sign that my eye level is lower than the base of the building. Again, any elements that I add must be viewed from a similar eye level.

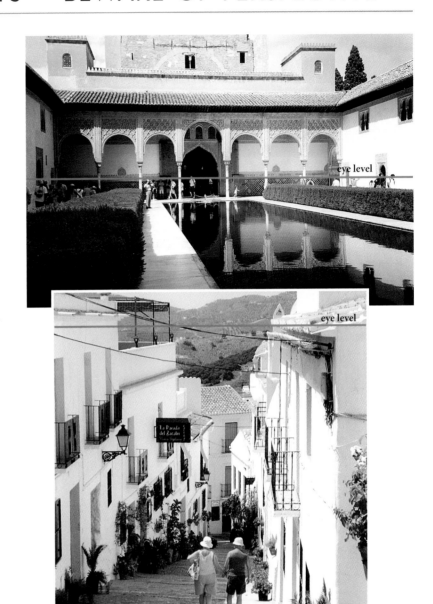

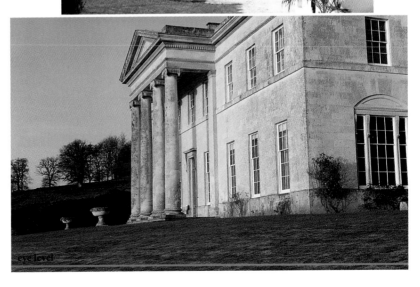

ADDING PEOPLE IN PAINTINGS

In the next three photos, you can see how figures will also relate to the eye level of the viewer. This fine group of people from one of my courses was coerced to pose for these shots. As with any random group, heights vary, but despite this we are aware that in the top photo my eye level is above the heads of the students. As with the perspective lines, the heads go up as they recede, and I am able to see the heads of those in the rear above those in the front. In any painting that has an eye level higher than flat ground, the figures will appear higher, yet smaller as they recede. The degree of angle will have to relate to other perspective elements within the subject.

When I am standing on much the same level as the group, allowing for the variety in height, the heads are on a broadly similar eye level. These people would fit in any subject based on a photo that was taken by me on level ground. As they become smaller with distance, the levels of their feet climb up towards the eye level as they recede. Their heads remain more or less level.

The final photo shows that my eye level is lower – more or less at waist level. See how the front figures obscure those behind, how the feet go up as they recede and how, generally, the heads echelon downwards to the eye level as they recede away.

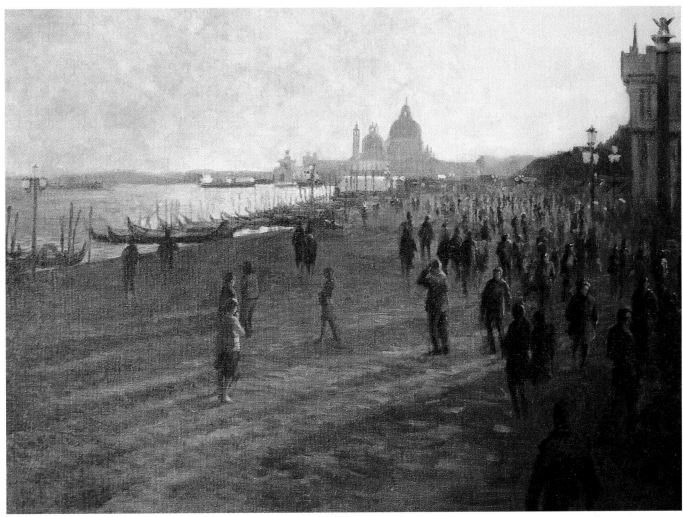

*ABOVE The Salute from the Ponte della
Veglia, Venice;* Tony Paul
Oil, 457 x 711 mm (18 x 28 in)

The painting "The Salute from the Ponte
della Veglia, Venice" features a high eye
level. The photo on which it was based
was taken from the bridge at a level
about 3 metres (10 feet) above the
promenade so we look over the heads of
all the figures in the painting. If I wished
to add further elements to this scene –
perhaps a souvenir stall – it would have
to be viewed from a high viewpoint to
match the perspective elements of the
rest of the painting.

In the close up, note where the eye
level is, and see how the figures' heads
are clearly visible above those in front
of them.

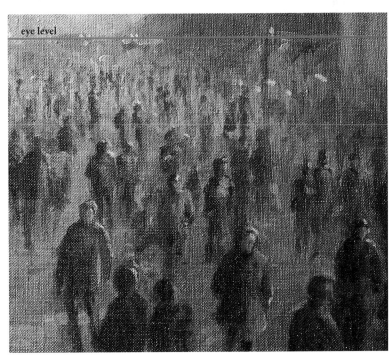

eye level

LEAVING THINGS OUT

We must never forget that the camera is an information-gathering tool. In itself, it doesn't have to be of high quality to do its job. In many ways a poor photo, providing it has the bare bones of what we need, can be better than a superbly taken shot, because we are more likely to adapt the poor photo, whereas with the 'super shot' we may be tempted to copy, rather than interpret.

I saw this terrace in Skiathos in Greece. It was caged in because it belonged to a house across the road and in the past had been used by holidaymakers without permission. The caging was forbidding, but I looked beyond the wire and padlocked gate and saw that it would make an interesting subject, overlooking the sea as it did. I liked the play of dappled light, the table setting and the vegetation. I felt that adding a glass of red wine would give a good focal point.

I used pastel applied to a red/brown pastel paper. The colour of this would prick through here and there and give the painting unity. There is a little more dappled light in my painting and, perhaps, the colours are a little brighter in places, but I feel that I have managed to keep a fresh quality to the work.

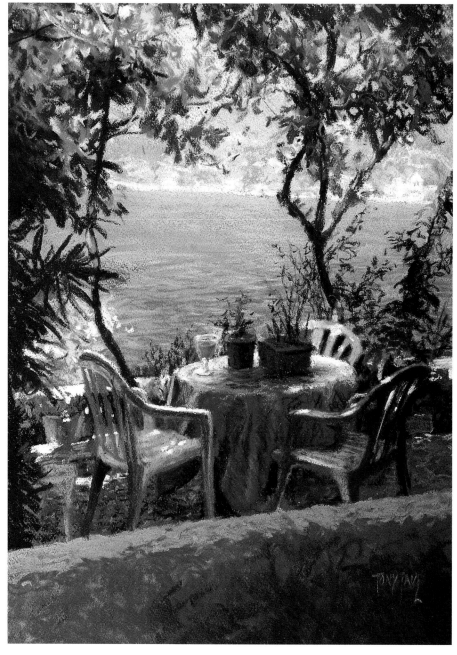

RIGHT A Nice Glass of Red,
Skiathos; Tony Paul
Pastel, 405 x 295 mm (16 x 11½ in)

For his pastel "Quiet Backwater, Venice", George Thompson has taken a subject crowded with detail, and softened and simplified it to give a compositionally satisfying painting. The original photograph, although clear and sharp, is very dense and heavy, with several centres of interest and tonal changes much the same in

the background as in the foreground. George didn't like the gondola in the foreground. He felt that the carpet runner's interest and tone drew the eye too much, but that, if it were simplified, it would become too ambiguous. He also left out the two poles in the water near the canvas-covered boat and reduced the two white bollards on the quay to one.

If George hadn't done all this, there would have been too much division of interest. In his pastel, the subject is less cluttered, and we are left in no doubt as to the focal point – the area of the bridge and the reflections of the buildings in the water beyond. His light touch with pastel has caught the tranquil spirit of one of the quiet backwaters of this lovely city.

BELOW *Quiet Backwater, Venice;* George Thompson
Pastel, 457 x 305 mm (18 x 12 in)

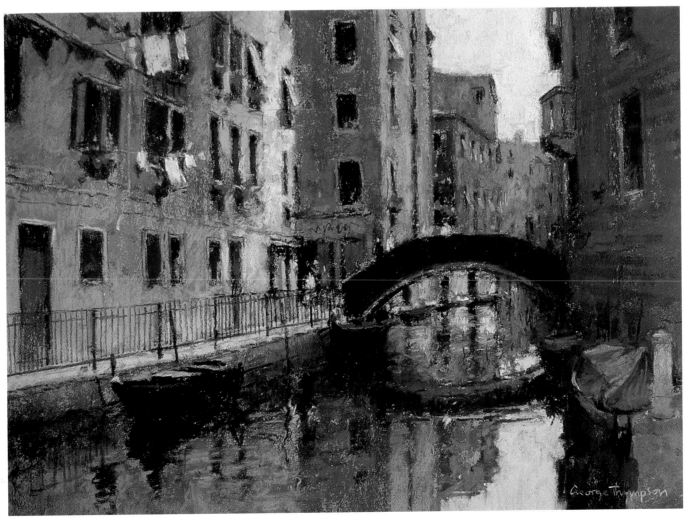

COLOUR SCHEMES

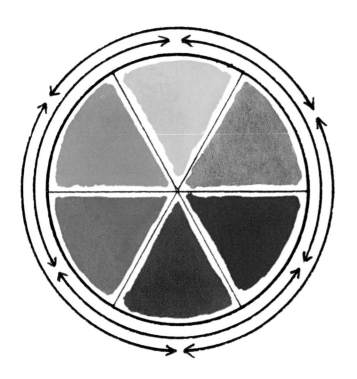

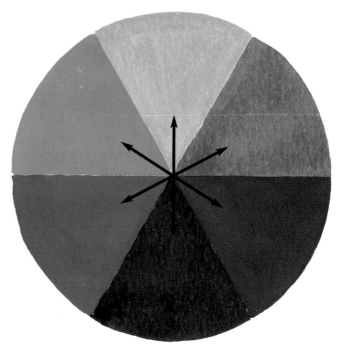

Harmonic colours

A harmonic colour scheme will consist of using up to three colours that lie beside one another in the colour wheel (see above). This colour scheme works because the colours are related – in the case of orange/yellow/green, the link is the yellow, which is in both the orange and the green. With yellow/green/blue, the link is the green, which is the product of the yellow and blue. The other related colours work in much the same way.

Complementary colours

Using colours that are opposite each other in the colour wheel creates another popular colour scheme. So, red will partner green, orange blue and yellow violet.

With both harmonic and complementary colours, we do not have to think of the colours as the spectrum hues shown in the colour wheels – orange could be a soft tan and blue a subtle bluish grey. It may be better to think of the possibilities as shades of blue, red, yellow, purple, green and orange, as opposed to pure colour. It is also better to allow perhaps one of the colours to dominate while the other or others act as support.

If you are unsure about which colours would be effective for a painting, one solution is to look for a subject with a particular colour scheme. Sometimes the subject is a ready-made colour scheme, such as the predominantly harmonic pastel on the opposite page. On other occasions, the colours can be changed, perhaps to complementary colours as in the watercolour overleaf. You may decide to make changes because the colours in the photograph are too raw, startling or dull, or because you feel the photos don't translate the colours as you remember them.

As you have learned, if you don't find the colours satisfying, you can change them. Looking again at Marita Freeman's painting of beach huts on page 25 will remind you how she injected something extra from her experience to lift the painting from the somewhat bland reference photographs.

Finding a subject with either a harmonic or complementary colour scheme is not too difficult. The red of poppies in a field of green wheat is a good example of a complementary colour scheme. A scene with purplish mountains, blue skies and green fields will make a good harmonic colour scheme. Of course there will inevitably be other colours in the painting, but these will play minor, support roles.

PAINTING IN HARMONIC COLOURS

As we can see from the photo below left, there is already a harmonic colour scheme in the subject. The three colours are blue, green and yellow – green being the link between the two other colours. I saw no need to change the scene and felt that the subject would best be painted in pastel.

I selected a brown pastel paper, chose the smoother 'wrong side' and laid in the darks with a charcoal grey.

Then I went for the lights – in this case the ochre-tinged gravel that edged the pond. I blocked in the water and the lily pads, and worked on the background vegetation and the structure of the arbour. I then went back over the painting, giving form to the vegetation, and putting detail into the pond and arbour. As before, I wanted the painting to be fresh and simply done, suggesting rather than detailing.

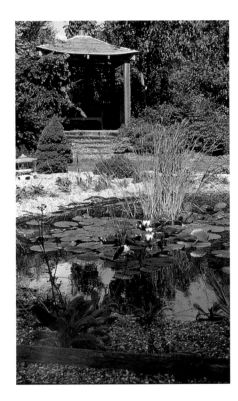

RIGHT Japanese Garden, Cookscroft,
West Sussex; Tony Paul
Pastel, 405 x 295 mm (16 x 11½ in)

PAINTING IN COMPLEMENTARY COLOURS

Winter subjects will often be dull in coloration. In his photograph, Snow at Westcott, David Wright has taken the photo looking into the light, which also gives strong tonal contrasts. When he took the photo, David noted far more colour than the photo revealed, so in his painting he relied on his memory, using the photo as a sketch, and taking the basic forms of the subject and then improvising upon them.

Whereas in the photo the line of the lane rises above halfway, David has placed it much lower in the painting, creating a bigger sky and allowing room for the invented trees on the right. He has also turned the light, making it come from the left rather than from the left front. This has enabled him to do away with the strongly tonal effects of the photo, giving the painting a lighter touch and more colour.

The coloration of the photo – mainly dark green and an icy blue – was not appealing, so David decided to use a colour scheme based on the complementary colours orange and blue. The orange in this case was of mixes of raw sienna and burnt sienna darkened with burnt umber. The blue was made using ultramarine with pale washes of alizarin crimson added to give a purplish element here and there. The oranges and blues were dropped wet-on-wet together to create the trees in the background, stronger and bluer for the snow-laden trees to the left of the nearer house, and more orangey and dilute for those in the background.

The resulting painting has a satisfying composition, relieved of the hard, dark tones of the photo. Its colour scheme is successful – a balance between warm and cool, with a unity created by the use of opposing and blended complementary colours.

RIGHT Snow at Westcott; David Wright
Watercolour, 299 x 419 mm (11³/₄ x 16¹/₂ in)

ADDING TO THE COLOURS

Colours can be added to a subject to create variety, or to explain more easily the relationship between one element of the painting and another.

For both these reasons I added to the colours for "The Barn, Earnley Concourse". I did this sketch as a demonstration for my students. It was painted in high summer, when most of the greens appear similar. This can make the creation of a sense of distance very difficult, as the trees all tend to melt into one confused plane. So to create the truth of the layering at the back of the landscape, we have to tell some lies in other respects, by changing, exaggerating and adding to the colours we see.

The photo, taken in bright light, has almost bleached out the grass; the darks are almost impenetrable, and the trees melt into one mass. Clearly, it wouldn't work as it was.

I used oil on a rough, primed panel for this demonstration. First, I reinstated the sky, which in the photo had totally bleached out. Then I began work on the trees. With my binocular vision I could determine what was in front of what, even though the colours were the same, but a painting has only one view, so we have to change the colours or tones, or both, to create a sense of depth.

The background trees had a soft blue-grey undertone, so I exaggerated this into a soft purple and brushed them in, changing the tones and colour a little to reflect the change of light.

The next nearest trees were to the left of the barn. I used ultramarine and yellow ochre to make a dull, warm green, adding white for the highlights. To make the shadow of the underside of the trees in this area, I added more blue to the mix and worked in a little of the dull purple to push it behind the roof. I felt that this coloration was, perhaps, a little bland, so I did what Constable often did – enliven it with a few touches of a complementary colour. I used some of my cadmium red mixed to be the same

tone as the green. I was pleased to see that it acted as shadow within the tree. Beneath the tree, I added some cool greens, implying undergrowth in shadow, and in brighter greens, I added the sunlit scrub in front of the fence. The tree on the right was made using brighter greens, which helped to pull it forward.

There was a reddish roller in the barn so I made it more prominent than it appears in the photo, and more colourful – a nice foil to all the greens. The freshest green was reserved for the foreground, which I varied with small strokes of other colours from the palette to give the impression of coarse grass.

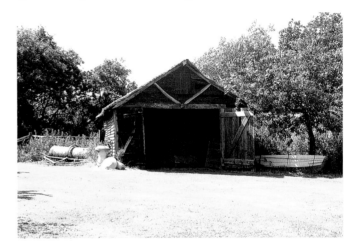

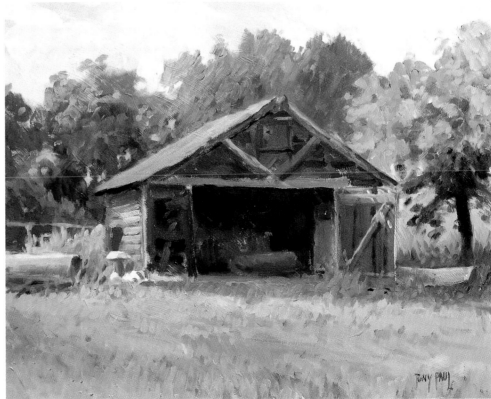

RIGHT *The Barn, Earnley Concourse;* Tony Paul
Oil, 305 x 381 mm (12 x 15in)

The photograph of the Eastgate, Chester, was taken on a sunny day. Although this is clear in the photograph, it didn't give George the sensation of the heat that he felt when he took the photo. Somehow, the sun appeared too watery, and the delicate blue sky with its light wispy clouds was totally bleached out. Sometimes photographs can be disappointing in this respect.

The tonal relationships in the photo gave a good sense of modelling, and George felt that with a little simplification a good painting would result. The foreground was too cluttered with figures, so these were culled, made smaller or moved so that the eye was drawn to the gate of the city wall.

He enriched the colours – see how dull the walls of the Eastgate appear in the photo, then note how they glow in the painting. Splashes of red punctuate the figures and the hanging basket, and the blue of the sky – bleached out in the photo – has a peachy undertone. In this painting, he has caught the warmth of that summer's day in Chester.

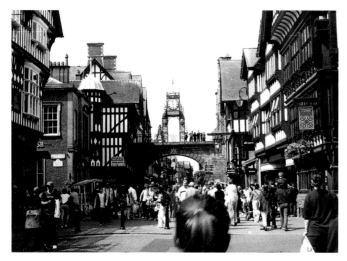

BELOW *The Eastgate, Chester;* George Thompson
Pastel, 279 x 381 mm (13 x 9 in)

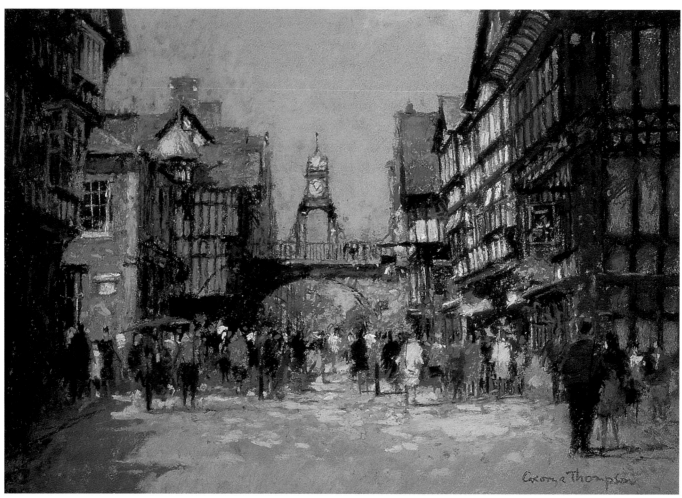

ALTERING THE LIGHT

One thing that the artist (or photographer) can never predict with certainty is the weather. We can set off for a painting site in blazing sun with total optimism, then find that by the time we have arrived and set up our easels (or cameras), the sun is obscured by a blanket of

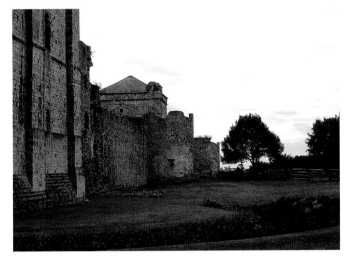

cloud that stretches from horizon to horizon. So what if we want to do a painting and the light is similar to that in the photograph – dull and overcast? On dull days, you get dull paintings.

What I did in this instance was to take a photo – see how flat it is with bleached-out sky and dark, lifeless walls – just for the information it gave me. At home, in the warmth of my studio, I began a watercolour in which I would change the light and colours to produce a more appealing image.

I decided that the light should come from the left. This way the light would be coming over the wall, casting a shadow across the green and enlivening the tower of the gatehouse and the tree. I got rid of the car and, in its place, put in a couple of figures to give a sense of scale to the walls and tower. I used a loose technique to achieve the look of a painting made on the spot.

BELOW The Gatehouse, Portchester Castle; Tony Paul Watercolour, 279 x 381 mm (11 x 15 in)

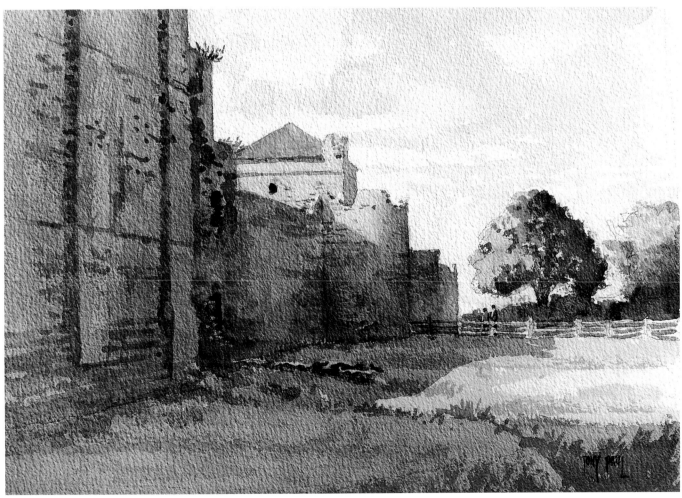

PAINTING LOW-LIGHT SUBJECTS

Generally, cameras do not work very well in low light. If you use film cameras, the speed of the film in the camera will be critical; with a digital camera you may be able to change the ISO setting for low-light purposes.

Whichever type of camera you use, camera shake will be your main problem. If you have no tripod with you, you will have to find another means of keeping the

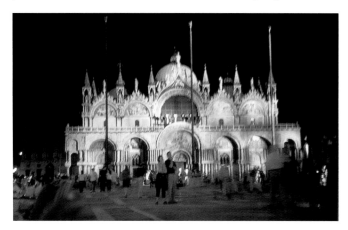

camera still. For the painting of San Marco, I held the camera, which was loaded with 100 ISO slide film, on the back of a chair to keep it still, setting it to automatic before pressing the button. The result was a photo good enough to develop a painting from.

I felt that the photo captured the atmosphere of the subject well, so when I did the painting I resolved to keep the mood of the subject. I used pastel because of its opacity and clarity of colour. Working on a purple-grey pastel paper, I laid in the darks around the church before using a range of bright yellows, creams, reds and blues to represent the brightly lit facade.

I used cool colours for the backs of the figures so that they would be in contrast to the hot colours of the church. As the photo was taken from a sitting position, I was careful to make sure that the figures receded into the distance in the correct perspective.

BELOW San Marco at Night; Tony Paul
Pastel, 216 x 305 mm (8½ x 12 in)

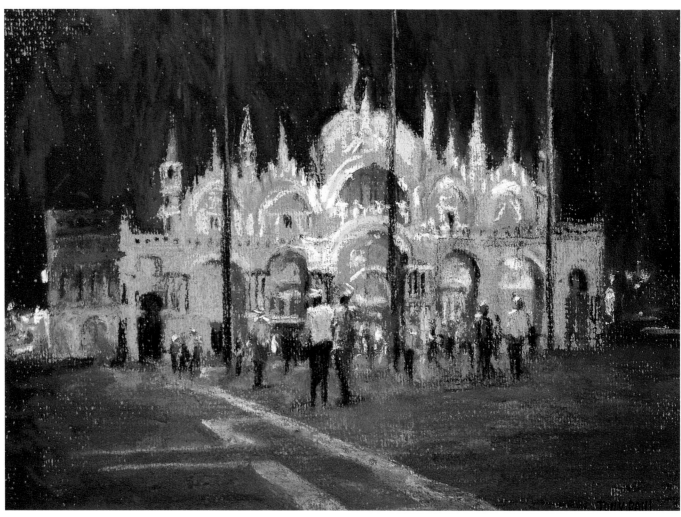

CHANGING THE SEASONS

The photograph of a barn in Bagneux, France, was taken one hot summer morning. The light was bright, and the photo has bleached the sky almost white instead of the clear blue that I saw. This barn is typical of many French agricultural buildings, once almost baronial – look at the dressed stone of the doorway and the plaque in its centre – but now in an advanced state of neglect. I loved the shapes and perspective of the view and the light on the distant trees and decided to do a series of three paintings, changing the colours and some of the content to give summer, autumn and winter versions.

If you have difficulty imagining how the changes of season would affect the subject, you can hunt through your own photos for appropriate season subjects and borrow the colours and other information from them.

The first painting, in watercolour, was the summer view based fairly literally on the photo. You will note that I have reinstated the clear blue of the sky and removed the car. But I kept the oil tank and corrugated iron to help with the impression of semi-dereliction. I wanted to push the distant trees further back into the picture, so I painted them with a dull purple rather than a bluish green. The watercolour was applied largely in loose, broken washes, using the rough texture of the paper to give dry-brush effects to describe the rough stonework and ground. I turned to pastel for the autumn version. The only greens that remain are in the grass, and even this has autumnal colours broken into it. The tank, corrugated iron and car have gone, and the light is softer with reduced contrasts. The distant trees, a brighter purple in the shadows than in the summer painting, have haloes of peachy orange, and the sky is streaked with cloud. I tried to create a loose, dry quality to the painting – the surface texture of the rough paper and the dry, granular character of the pastel both helped to achieve this.

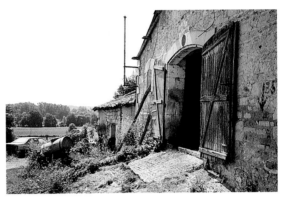

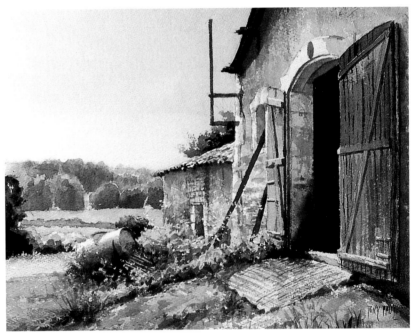

*ABOVE Barn at Bagneux, Summer; Tony Paul
Watercolour, 279 x 394 mm (11 x 15½ in)*

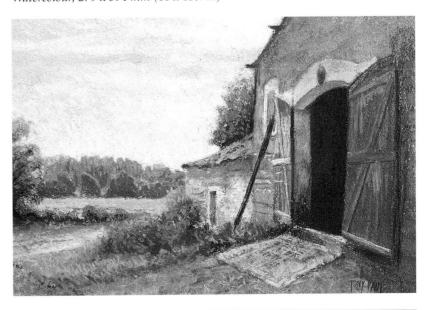

*RIGHT Barn at Bagneux, Autumn; Tony Paul
Pastel, 254 x 381 mm (10 x 15 in)*

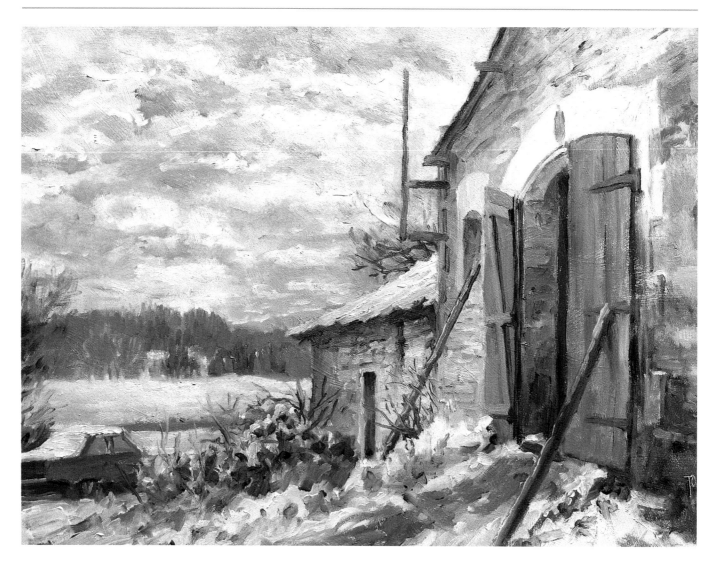

My final painting – an oil – sets the subject firmly in winter. Whereas in the autumn version the colours, even the purples, were on the warm side, in this version all the colours are cool. The steely blue-grey background trees are thinner without their leaves, and the snow on the hill can be seen through them. The thick oil paint has been used to describe the snow, piled on the grass and bushes. Where the cattle have trodden the snow, it is suitably greyed. I have reinstated the car and closed one of the barn doors, bracing it shut with one of the poles.

The painting was done loosely, again relying on the texture of the rough, primed board to help with the quality of the brushwork. No attempt was made in this, or the other two versions, to copy or create a photographic representation of the subject. First and foremost, it has to look like a painting with the alive, fresh quality of one made while standing in front of the subject.

ABOVE Barn at Bagneux, Winter; Tony Paul
Oil, 267 x 343 mm (10 x 13½ in)

PART FOUR
PAINTING IN VARIOUS MEDIA

WATERCOLOUR

Watercolours are the medium of the moment, having been popularized by television programmes and countless books on the subject. Much of the appeal is that they are clean to use, odourless, easy to pack away upon the close of a painting session and, in skilled hands, can give fresh, colourful effects fairly quickly. But watercolour is arguably one of the most difficult media to master. Unlike with oils, you cannot paint light over dark because the colour is transparent, and errors are often difficult to correct.

Watercolours come in two forms: pans, which are square or rectangular tablets of colour, easily melted with a brush; or tubes, which deliver the colour in a thick paste much easier to dilute into a richly coloured wash. Pans are best used for small paintings or sketch-book work, where limited washes will be needed, while tubes excel for larger paintings and big washes.

Unlike many other media, pale colours are achieved in watercolours by diluting the pigment with water, rather than by adding white, which, in watercolour, tends to deaden the colours.

Without doubt, watercolour is at its best when used in fluid washes. The brush should be loaded with diluted colour and applied briskly – a meanly loaded brush applied piecemeal is likely to give a streaky, worried look to the colour. It will not have the vibrancy or texture of a wash that has been applied with gusto. The strength of the colour will depend on the ratio of pigment to water in the wash, pale washes using less pigment than vibrant ones. Even dark colours should be applied in a fluid way, mixed to be dark when fluid, rather than put on thickly, when they quickly look incongruously heavy and dead. The one exception to this is the use of white, which should be used sparingly to put in small highlights or accents.

LOOSE WASHES

Alan Simpson never works directly from photographs. If his time is limited, upon arriving at a painting site he will do a sketch here and take a photo there, all the while drink in the experience of being there. It is only later in his studio that he will use his recollections and the information contained in his sketches and photographs to work a final sketch, which will be turned into a painting.

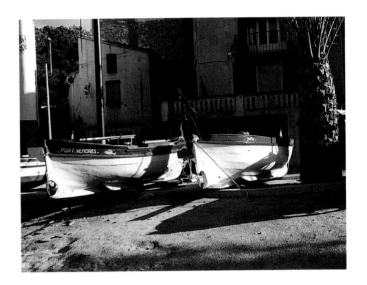

You can see that the boats have been used and the balcony remains. However, the boats are viewed from a different angle – taken from a sketch. The figures come from another sketch and the flagged buoys are taken from yet another source. The character of the light and some of the colours are evolved from the photos and expressed in a lively, painterly way. This gives the painting its sense of drama.

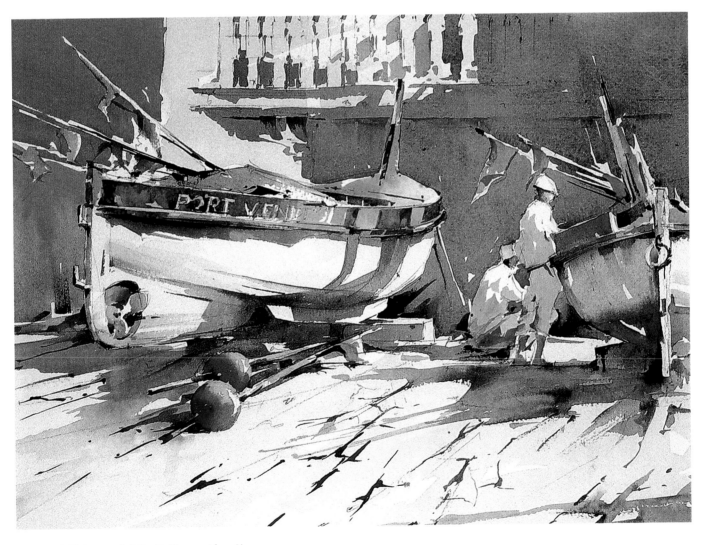

ABOVE A Fisherman's Life, Collioure; Alan Simpson
Watercolour, 356 x 533 mm (14 x 21 in)

A FULLY RESOLVED WATERCOLOUR

Watercolours do not have to be applied in a loose, impressionistic way, using big brushes. Although my watercolour "The Blue Bucket" is more resolved, I still used the watercolours in a fluid and joyful way, but with smaller brushes. The translation of the photograph was fairly literal, but I made sure that the painting was clearly a watercolour, and no attempt was made to make it look photographic. Neither have I tried to transfer the waves in the water wave by wave. Apart from the wave breaking on the shore, which is fairly literal, I have used happy accidents on the washes as a base for the modelling of the sea.

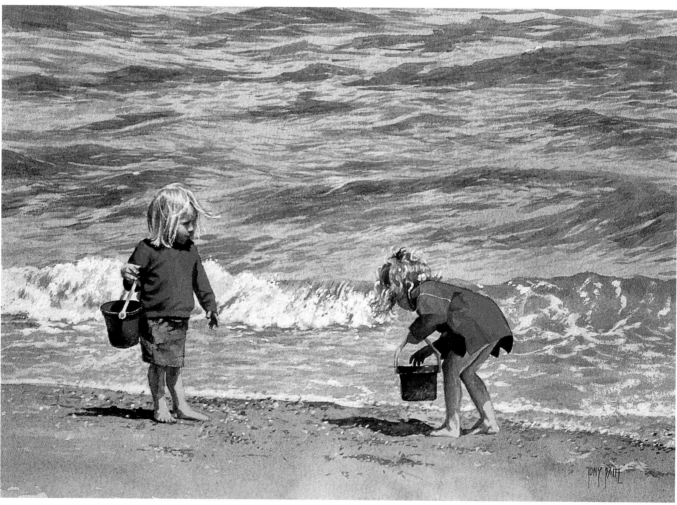

ABOVE *The Blue Bucket;* Tony Paul
Watercolour, 305 x 406 mm (12 x 16 in)

OIL PAINT

Oil paint is often the preferred medium of professional painters. It is easier to use than watercolour. White is used to lighten colours, lights can be painted over darks and mistakes can be rectified with ease either by over-painting or wiping off. Oil paint is normally diluted with a solvent such as turpentine, but certain types, such as Winsor & Newton Artisan and Grumbacher Max, have been modified to be water-mixable.

The colour is buttery, verging on the opaque, but transparent colours such as ultramarine or alizarin crimson will still maintain their transparency if applied thinly or mixed with a painting medium.

Alla prima technique

The 'alla prima' technique involves painting a picture in one go, without waiting for the paint to dry. Sometimes this will be in one session, or over two or three days, bearing in mind that, depending on the pigments chosen, the surface on which it is painted, the thickness of the paint and the weather conditions, the paint can take more than a week to dry.

Most painters use this technique for spontaneous, lively, impressionistic work. There are few technical rules to abide by when using this method. The paint is usually applied densely, sometimes straight from the tube, without any solvent being added. Many painters favour oils' opaque colours.

Multi-layering

The old masters such as Rubens, Rembrandt and Leonardo da Vinci used a multi-layering technique, working from a largely tonal underpainting, through several superimposed, transparent layers of colour, to achieve the finished result. Each layer has to be dry before the next can be applied. This imposes restrictions on the painter. Because of the nature of oil paint, certain pigments need more oil than others to make a satisfactory paint film. Similarly, some pigments will dry faster than others. The artist has to be careful that the colours in the underlayers are leaner in oil and faster drying than those applied over them. Failure to observe this 'fat over lean' rule could result in sunken dead patches and unsightly cracks appearing in the surface as the long drying process – it sometimes takes years – proceeds.

The overlaying often takes the form of glazes – transparent colours thinned and rendered more trans-parent by using painting mediums such as Daler Rowney or Winsor & Newton oil painting mediums. Great depth, particularly in the darks, can be obtained using this technique.

OIL PAINT – ALLA PRIMA TECHNIQUE

Small works, simply done and without too many fiddly bits, lend themselves to the alla prima technique; it can be tricky trying to resolve small, complicated, fine details over an underlayer of wet paint. The paint on the brush can skid across the wet paint or blend with it, the underlayer then softening the effect of the added colour.

In the photo of the beach of St Ives, I liked the light on the boats, and their shadows against the brightly lit sand. The figures were useful because they punctuated the rather horizontal elements, provided interest and gave a sense of scale to the boats. I took a rough, primed panel tinted with a cream colour. Its coarse texture would stop

me from getting too fiddly. I felt that the overall cast of the photo was too cool, more like winter sun than the hot summer sun that we experienced, so I decided to warm up the colouring.

After drawing the subject on the panel in dilute burnt umber, it was blocked in with slabs of colour of appropriate tones, applied so that they met, but did not overlap. I kept the shapes simple, concentrating on getting the forms right. These were then modified with finishing touches that suggested detail rather than expressing it in a highly resolved way. The wet underpaint wouldn't have allowed that approach anyway.

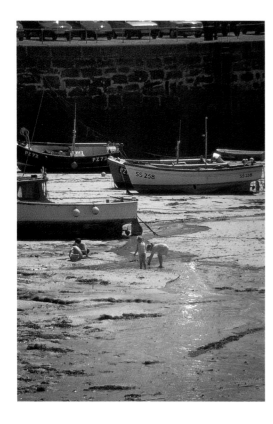

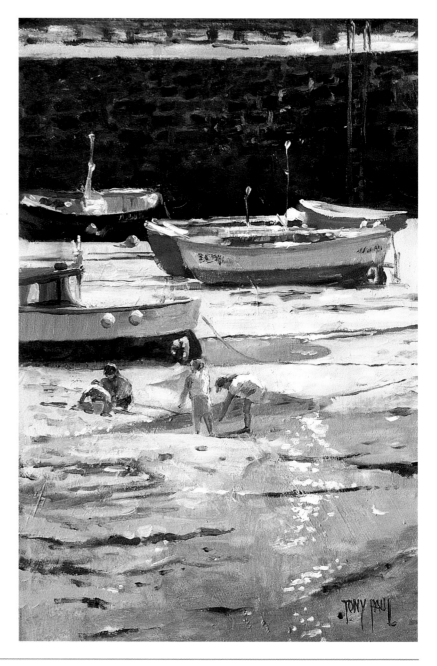

RIGHT Low Tide, St Ives; Tony Paul
Oil, 305 x 197 mm (12 x 7¾ in)

OIL PAINT – LAYERED TECHNIQUE

The photograph on which Peter Kelly based his painting "The Rehearsal" is clearly a reference providing little more than information. There is a totally different atmosphere in the painting. For instance, in the photo we have divided interest: our eyes jump from pianist to cellist, and both are of equal importance. The former is

dark against light, and the latter is light against dark. This makes for poor composition. Instead of one player dominating, we have two players performing with equal volume, but different melodies. It's confusing.

Peter's experience and skill told him that to make this painting work, he had to make one of the figures dominate, while the other played a supporting role. So, because of the interplay of the bright light from the Anglepoise lamp and the darkness of her clothes, he chose the pianist to be the main focus, while the cellist is relegated to a supporting part in the shadows.

Peter also reinforced the large, abstract shapes of the carpet and the wall behind the pianist to simplify the bitty nature of the photo's background. His strongly tonal underpainting and trademark sonorous dark glazes have put great depth into the painting and given the subject a mood totally lacking in the photo. The music scattered on the floor adds depth to the figure of the cellist and breaks up what would otherwise be a large area of plain carpet.

ABOVE The Rehearsal; Peter Kelly
Oil, 381 x 533 mm (15 x 21 in)

PASTEL

Pastel is little more than pigment made into a stick. Because it cannot be easily lightened or darkened, each colour is produced in a range of different tints (paler colours) and shades (darker colours). Pastels are used, in the manner of chalks, on a paper with an abrasive surface that will hold the pigment. Special papers, boards and sandpapers are produced specifically for use with pastel and will give varying hold to the pastel, some holding a lot of pigment before clogging.

See how David Wright has used the photograph as a sketch, simplifying many of the elements in the photograph and changing the time of day to sunset. Working on a 'toothy', dark gold-coloured paper, he has used the sides of the pastels to produce broad effects. He has used a light touch for the upper sky and pressed harder for the band of cloud and the remainder of the painting. The corners of sharpened pastels and pastel pencils have been used to create the finer details.

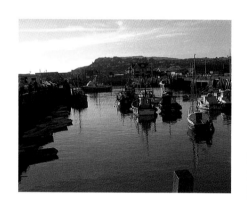

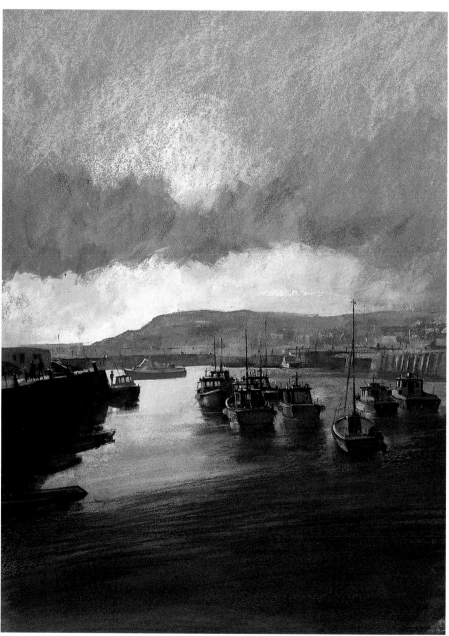

RIGHT Evening, West Bay, Dorset;
David Wright
Pastel, 600 x 440 mm (23⅝ x 17⅜ in)

GOUACHE

Gouache is basically opaque watercolour. It is made this way either by packing the paint with dense opaque pigment or by adding an opaque filler to the pigment. Unlike with pure watercolour, the user is able to paint light over dark, more in the manner of oil paint. The colours are usually vibrant and are made in a large range of bright colours. There is a distinct change of colour as gouache dries, particularly if white is added to the mix, with light colours becoming darker and dark colours lightening. This has to be borne in mind when painting.

I took the photo on the right with a 35-mm camera loaded with slide film. To avoid camera shake, I rested it on the handrail of a bridge and set the camera on automatic to expose the film.

Gouache was ideal for the subject, with the bright château appearing like a gilded palace against the purple of the sky. The light colours representing the street and car lights that were applied over the initial dark lay really glow and the colours are rich and full.

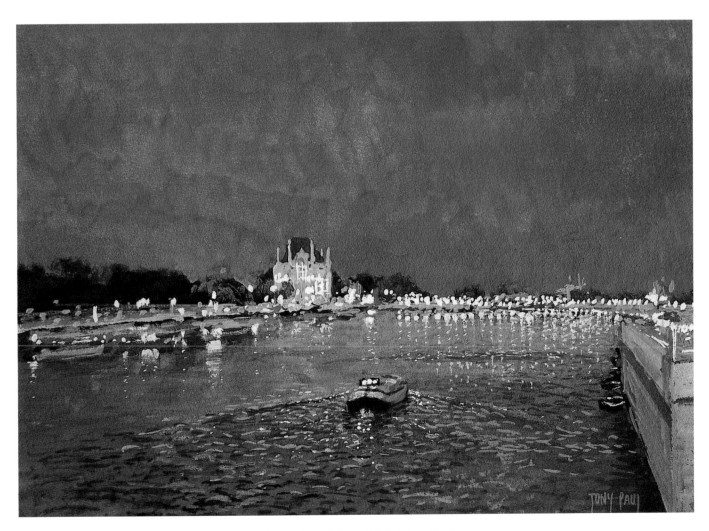

ABOVE The Seine at Night; Tony Paul
Gouache, 228 x 305 mm (9 x 12 in)

ACRYLIC

In many ways, acrylic is the most versatile of painting media. It came into artistic use in the 1950s and was hailed as the paint that would render all others obsolete. The fact that this hasn't happened is due more to the special characteristics of other media than any lack of versatility on acrylic's part.

Acrylic is capable of both opaque and transparent techniques and will work in thin washes and impasto, even in the same painting, without creating any technical problems. It has little smell, mixes and cleans up with water and dries quickly by evaporation. The acrylic resin in which the pigments are bound is very transparent, and sometimes care has to be taken to avoid the colours in the painting becoming garish.

In her painting of Piazzetta Pattari in Milan, Teresa Zwolinska-Brzeski has used acrylic thinly and fairly flatly. She has simplified the subject, which on the right side is very complex, and rendered it largely in monochrome, with just a touch of red and blue. The figure of the beggar is also in monochrome, the only real colour being in the blue walls of the buildings and the black and yellow hazard-warning tape. The colour has separated the right-hand group of figures from the beggar, yet their monochrome treatment unites them. In all cases, the paint has been applied in thin glazes one over the other, creating a pleasing texture. The completed painting is more dynamic than the photograph, with the detail reserved for the subject – the beggar.

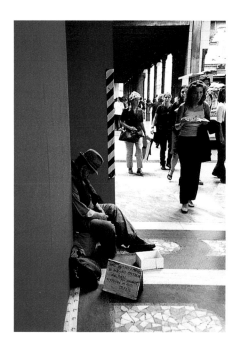

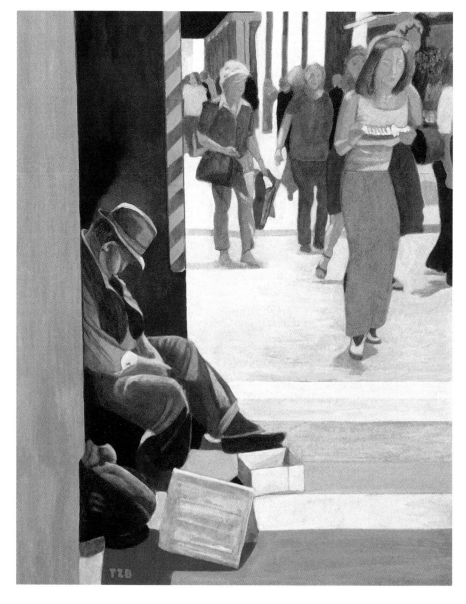

RIGHT Piazzetta Pattari, Milan;
Teresa Zwolinska-Brzeski
Acrylic, 508 x 406 mm (20 x 16 in)

COLOURED PENCILS

Coloured pencils have come a long way from the simple and cheap ones that we might give to our children to draw with. Nowadays, there are many brands that are produced especially for professional artists. They're not cheap but do have such features as good lightfastness and brighter, more powerful colours, with many based on pigments rather than on dyes, which can readily fade.

Some people may think that coloured-pencil work is easy, barely more than scribbling. But it isn't easy if work of any strength or quality is to result. Strong pressure, many layers of colour and constantly sharp pencils are all very important. Jonathan Newey's portrait of a leopard was carefully built up with many layers that created the texture of fur and skin.

*ABOVE Portrait of a Leopard; Jonathan Newey
Coloured Pencil 305 x 356 mm (12 x 14 in)*

EGG TEMPERA

Egg tempera is made by the artist just prior to use. A blend of pigment, egg yolk and water are the only ingredients, making a very pure and powerful paint. As you can see from the photograph, areas of light have bleached out, and other areas have become impenetrable darks. I made these areas work by adding detail into them, using a blend of calculation and guesswork to create the missing forms.

Because small brushes were used to apply the quick-drying paint, textural effects and fine detail were easily obtained, and although the detail is there, it still has a painterly feel. Compare the bucket in the photo with the painted version – although I have made it look realistic, it is not photographic.

Much of the underlying work was done by sponging one layer of colour over another. This can easily be seen in the portrayal of the ground. Imperfections in the sponged areas were utilized to make the small stones and twigs that litter the floor of the barn. The remainder was applied by brush in a small, yet painterly, way.

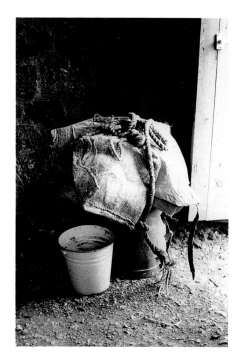

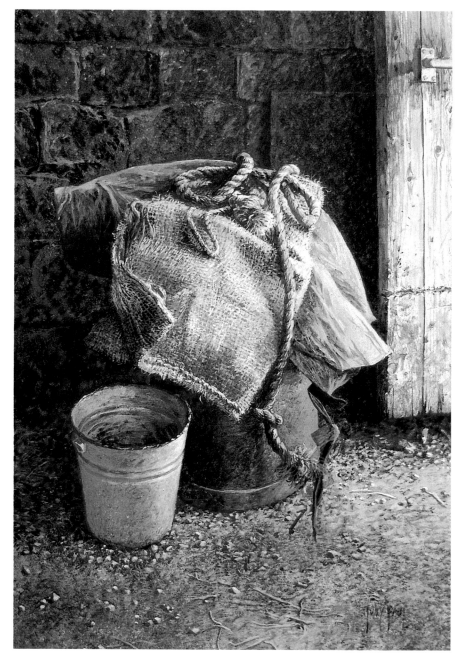

RIGHT In the Barn at Noisy Dave's; Tony Paul
Egg Tempera, 401 x 305 mm (16 x 12 in)

PAINTING A PICTURE USING TWO PHOTOGRAPHS

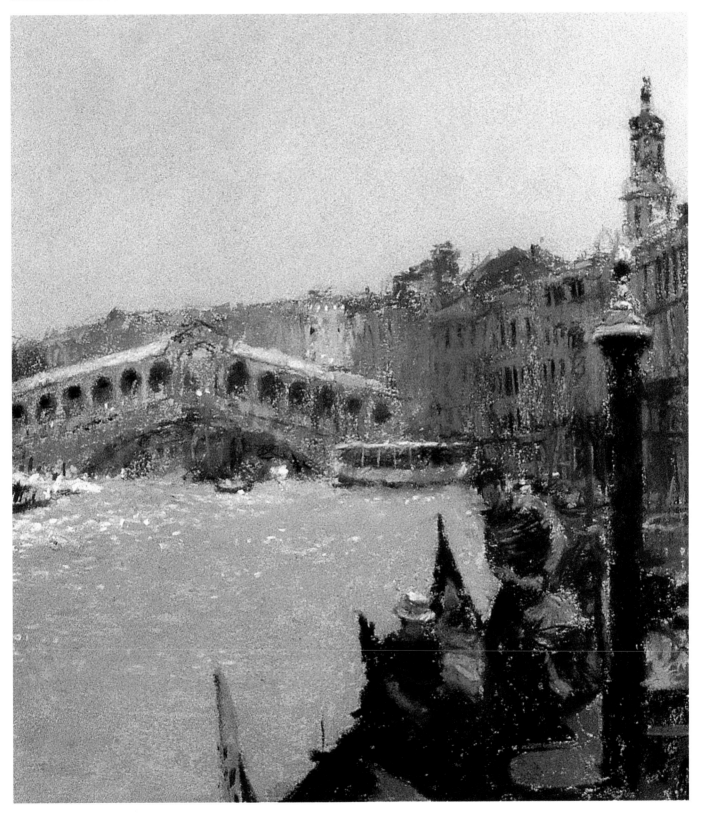

ABOVE The Rialto Bridge (detail), Venice; George Thompson
Pastel, 356 x 508 mm (14 x 20 in)

PAINTING A PICTURE USING TWO PHOTOGRAPHS

THE PRELIMINARIES — SELECTING THE PHOTOGRAPH

Rod Jenkins first saw this scene on his way to King's Lynn and was immediately smitten. The scene is very English: the River Wissey, just north of Hilgay in Norfolk, is tranquil, with its moored boats and the lush landscape receding back into the distance. He subsequently stopped on various occasions and took photographs, and when I asked him to do a watercolour and an oil of the same subject for this book, he thought that this scene would fit the bill perfectly.

The top two photographs were taken in the afternoon, with the light coming from the left and modelling the trees so that they read against one another. The first one is viewed from the road bridge, and the second from the approach to the lane. He took the third shot at a later time, early one summer's evening. The subject now is contre-jour and more strongly tonal than the other two photos. Note how the sky and areas of the river are bleached out, while detail and form are difficult to see in the darks.

Rod decided against the contre-jour view, preferring the warmth of the earlier afternoon shots. He based the painting largely on the centre photo, but liked the full reflection of the main boat as seen in the top photo and so widened the river slightly to accommodate it.

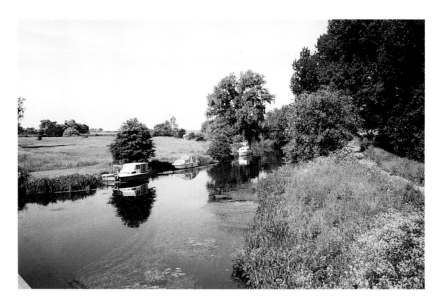

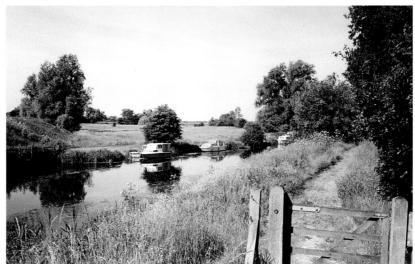

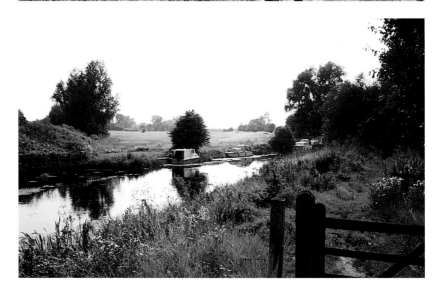

SKETCHING IT OUT

For the watercolour painting a good-quality 600 gsm (300 lb) rough watercolour paper was chosen. In watercolour painting the transparency of the colours is an important feature, so the quality of the paper is important.

The drawing, in soft pencil, appears, perhaps, too boldly done. Many students would have used a delicate touch so the following washes would easily hide the drawing. But when you look at the drawing, you are seeing it against pristine white paper, paper that is about to be covered with washes of varying strengths. One of my complaints about many students' watercolours is that they are too insipid. I have often asked students why they have done such wishy-washy work. Often the response is that they were terrified of losing the underlying drawing. It is amazing how even a moderately pale wash can hide softly drawn lines totally. If, on the other hand, you draw clearly, as Rod has done, the tendency is to paint more boldly, if only to hide the initial drawing. Having said that, it is quite nice to see the drawing showing through here and there.

Before painting the oil version, Rod stained the white, primed canvas with a wash of burnt sienna that gave a warm mid tone. Most oil painters prefer to work in an opaque way, and when working on a toned canvas, it is easier to pull out the lights and push back the darks from the mid tone rather than fight the white until the canvas is covered.

The brush drawing was done in burnt sienna with darker accents filled in. Burnt sienna is a good choice for drawing as it is a fairly weak colour. Any residue picked up by the brush on subsequent paint layers will not affect the overlaid colour too dramatically, particularly if the paint used for the drawing is kept thin.

In both cases, the drawing was kept simple. If the drawing were complex, there might be a tendency for the artist to 'fill in' the drawing with colour and end up with either a stilted or timid-looking painting. What we are looking for is a fresh and lively approach.

RIVER SCENE IN WATERCOLOUR

Stage 1: Before beginning to paint, Rod masked out areas of paper that he wanted to preserve as white with masking fluid. When this was dry, he applied fluid preliminary washes of varying densities. Ultramarine with a touch of light red was used for the sky with some added raw sienna. The greens, made of ultramarine and raw sienna, were warmed here and there with light red, and the darks were made from ultramarine and light red. Much of the colour was applied wet-on-wet, the colours fusing and softening. Some areas were allowed to dry before other washes were applied. Even at this early stage, Rod was not afraid to use strong darks. See how the masking fluid has repelled the overlaid paint.

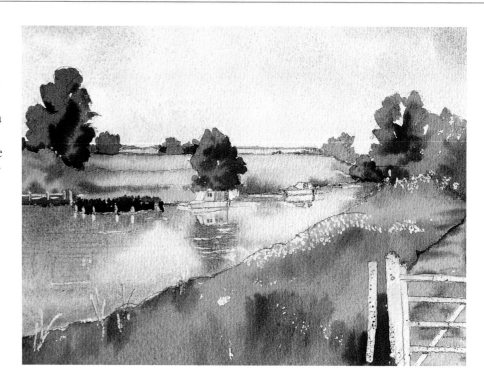

Stage 2: The second stage is one of reinforcement. The first layer was allowed to dry thoroughly before the dark ultramarine and light red shadows were added. The water received a lot of attention, being painted wet-on-wet on the far bank and in the boat's reflection, while being painted using a dry brush in the reflection of the left-hand tree. The masking fluid gives the water a horizontal emphasis, which implies 'surface', while the reflections tend to imply 'depth'. Combined, they create the impression of water. The masking fluid on the gate has been removed and an underlay of colour washed in.

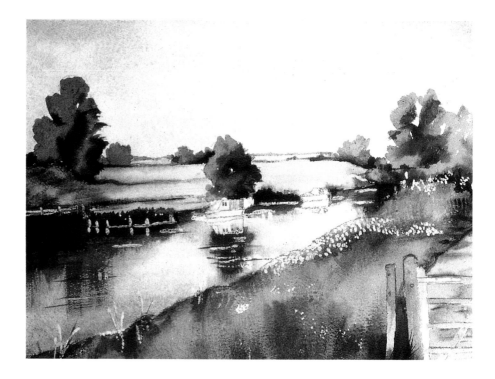

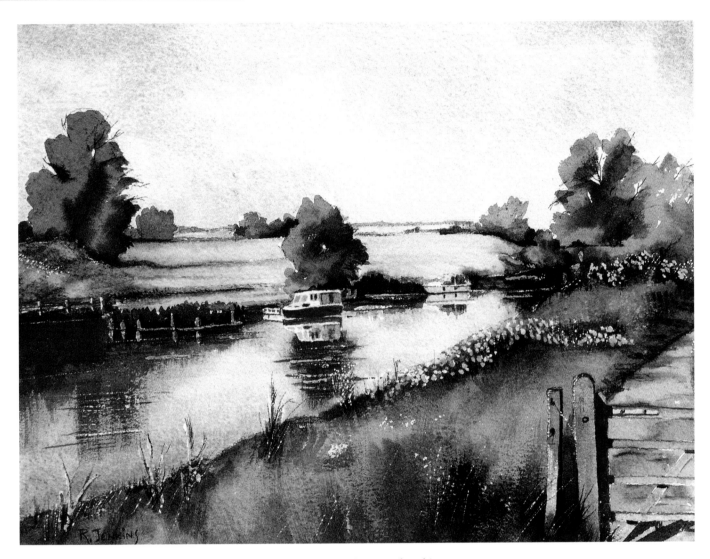

ABOVE River Wissey; Rod Jenkins
Watercolour, 279 x 381 mm (11 x 15 in)

Stage 3: The bulk of the work is now done, and it only remains to work on the boats and define small areas. Rod began this stage by removing the remaining masking fluid. A small brush was used to define the detail of the boats. See how perfectly he has represented the shadowed side of the distant boat, leaving a thin line of white paper along its top edge. The mirror reflection, slightly deeper than the boat itself, works well against the dark shadow behind it. The main boat has been represented equally well.

The gate was next to receive dark emphasis, and the rails were given touches of colour to describe them. Masked areas were painted in, with raw sienna applied to indicate the yellow wild flowers on the river bank.

Finally, Rod added some fine details such as the sparkle on the water and the small seed heads and grasses by scratching the surface with a sharp, pointed blade. This gives an altogether finer effect than could be obtained using masking fluid. The other option would have been to use Chinese or titanium white watercolour, or white gouache to represent the glints of light on the water.

The final painting is a lively interpretation of the photograph that appears as fresh as if it had been painted from life. Painting on site would have been difficult and perhaps a little dangerous, as the view is from a busy trunk road with only a small verge. Even when taking the photographs, Rod was buffeted by gusts, created by the constant stream of enormous lorries.

RIVER SCENE IN OILS

Stage 1: Burnt sienna and ultramarine were used to define mid and dark tones in a monochrome lay in. Already form is coming into the trees; the smudged areas in the river and the reflections look convincingly watery.

If the drawing is correct and the tonal structure works, the painting is well on the way to success. The application of colour is often just the cherry on the cake, the important, structural work having been done.

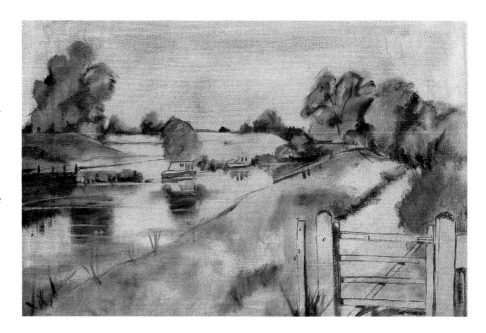

Stage 2: Rod has emphasized the blue of the sky. He remembered that it was less washed out than it appears in the photo. The white of the clouds gives an interesting line to the horizon.

As the colours are applied, we become aware that the underlying burnt sienna of the toned canvas is apparent here and there. Where this pricks through, it gives a unity to the painting. The background is resolved almost to completion. The boats are defined carefully, making sure that the shaded white of their hulls and cabins reads as such, against the pure white of the sunlit parts.

With the underlying paint doing much of the work, this stage is quite speedy. See how elements of the burnt sienna show through the scumbled paint of the water, giving it a reflective and truly watery character – this would be almost impossible to achieve in any other way.

The paint is still being kept fairly thin. Applying thick paint too soon in an oil can make overpainting tricky, with paint sliding over the underlying wet paint or just lifting it off.

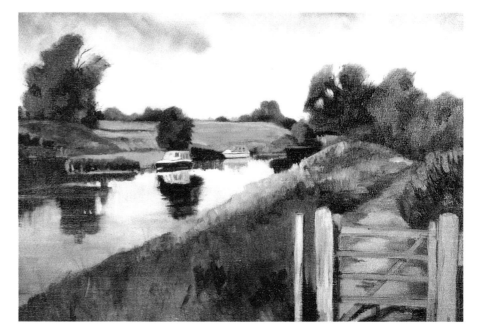

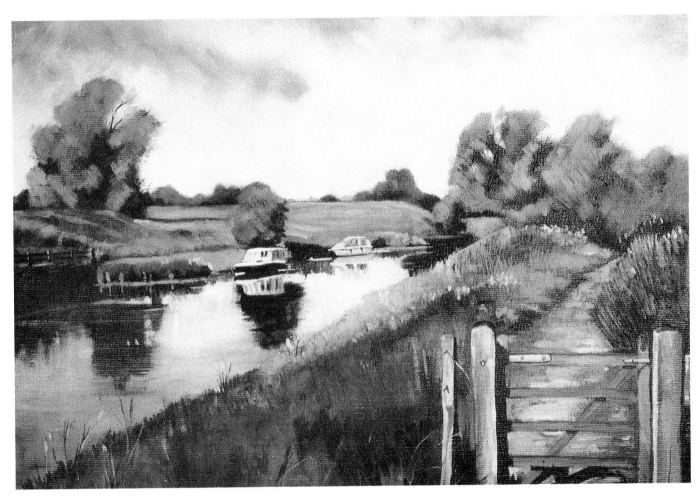

ABOVE River Wissey; Rod Jenkins
Oil, 305 x 247 mm (12 x 16 in)

Stage 3: The final stage in this painting is one of refinement. The middle-ground trees are swept with dry greens, streaks of light are put into the fields, the river banks are defined and detail is put into the boats. The river bank, with its rash of yellow wild flowers, is brought to life with suggested detail, and finally the gate is brought into sharp focus.

The difference between Rod's watercolour and oil interpretations is not that great. In both cases the drawing stage was followed by a tonal underlay – in the case of the watercolour this was, necessarily, in colour. Following this stage, colours and tones were strengthened and, in the final stage, the paintings tightened to bring out detail. Of the two, the watercolour is looser, relying on wet-on-wet washes to achieve texture, while it is all about brushwork and overlays of colour that give richness to the surface quality of the paint in the oil. The watercolour hasn't the weight of the oil in terms of density. Sometimes watercolours are referred to as the 'string quartet' of painting media, against the 'symphony orchestra' of the oil painting. The fact that they are so different in terms of application forces different approaches on the painter. Both paintings have succeeded in capturing the tranquillity of a quiet sunny day by the river.

VENETIAN SCENE IN PASTEL

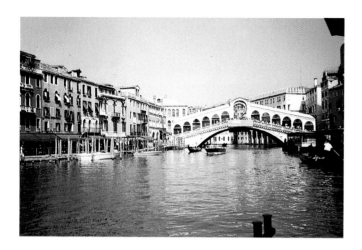
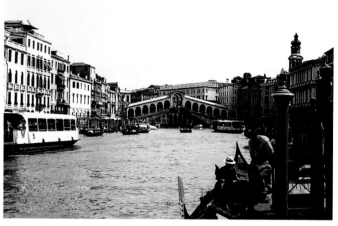

The first photograph of the Rialto Bridge was taken when the light was almost squarely on the bridge. Although he liked the subject, and particularly liked the reflections in the canal, George Thompson felt that a more distant and less bright version would improve the composition. He chose a warm-coloured paper for the painting and began by making a careful drawing in brown pastel pencil. Perspective is important in a subject like this, and he was careful to get it right in the initial stages.

Stage 1: He began painting by blocking in the main areas, working from background to foreground – see how the blue of the sky has been applied in a broken way to allow the warm colour of the paper to show through. In this stage, he is only concerned with the basic shapes, colours and tones.

Stage 2: Suggestions of windows and other details were applied to the left-hand side, and the shadowy right-hand side and the water were loosely blocked in. Note how George made the tones of the water bus and the embryonic right foreground darker to pull them forward.

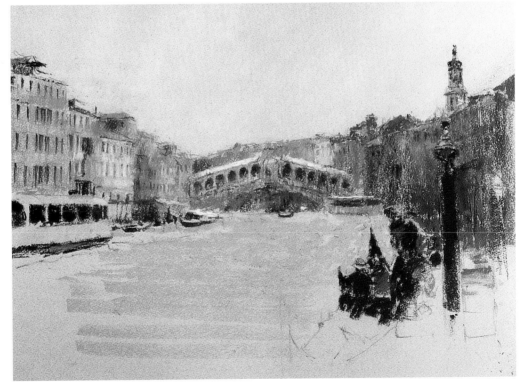

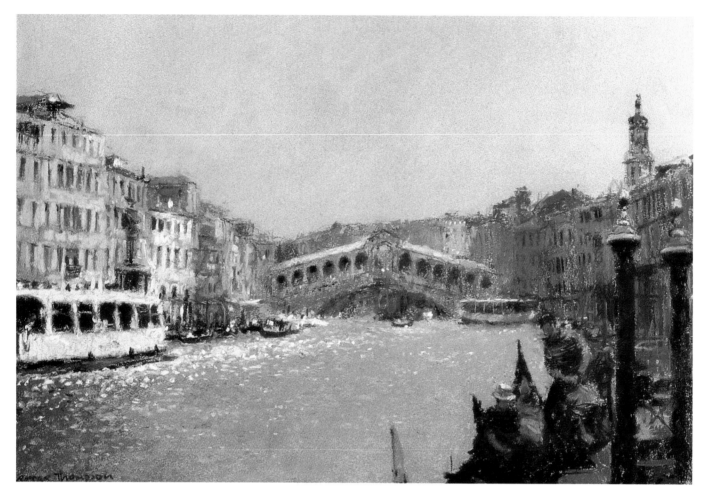

ABOVE The Rialto Bridge, Venice; George Thompson
Pastel, 356 x 508 mm (14 x 20 in)

Stage 3: Once the whole painting was completed in rough, the background was worked over again, tightening shapes, adding windows and resolving roof shapes. The right foreground was resolved, being careful to keep the tone low enough to prevent it becoming too much of a focal point.

The water was the next area to receive attention. The photo that George had used as the main reference showed very little in the way of reflected light in the water. He wanted to liven it up a little, so he improvised on the reflections in the first photo and gave it life.

By now, the painting was almost complete. Final touches – tiny points of colour in mainly white and bright red – enliven more neutrally coloured areas. In subjects such as this, the white specks are highlights reflected off something. It doesn't matter that we don't know what they're reflected from, and it doesn't matter what the coloured specks represent, they just add variety and a suggestion of detail into blander areas. Don't overdo them, though – less says more in this case.

Looking at the painting, it has the freshness of touch that suggests it was done from nature, even though it was painted from photographs. If we look at the photo, the tones are compressed and hard, and do not soften with distance. The painting, however, has a fine sense of distance, a delicacy of colour and a soft quality, all of which are far more true to Venice, than anything in the photo.

I don't think that George would have made such an evocative painting had he not visited, and soaked up the atmosphere, sights, sounds and yes, now and then, smells, of Venice. To truly capture its character, you really do have to go there.

FIGURE PAINTING IN EGG TEMPERA

I liked the idea of this ambulance man being cornered by the smaller man, who then regaled him with his life story and opinions. I took the photo of the figures in a small mall, but felt that the background was a little too busy. I also wanted to give the impression that the uniformed man had his back to the wall, so I went down to the local shopping parade and took several photographs of possible backgrounds. I chose one of a bank wall, which I felt would reduce the depth of field of the painting and give more of an impression of the taller man being trapped. I also changed the angle of the ambulance man's head to make him look more quizzical.

Stage 1: After drawing out the subject, I began working on the background stone wall, at first sponging it, then working into it with a splayed brush. I brought the cashpoint and stonework up to a reasonable degree of finish and mapped in the tones of the rest of the painting, describing the form in the smaller man's blouson and simplifying the window by leaving out the blind.

Stage 2: I modelled the ambulance man's tunic, working over the deep blue with a paler blue-grey applied using hatching strokes. This gave him form and brought out details such as his pockets and collar. I used the same technique on his cap and trousers and then put in the buttons that I had accidentally overpainted. I then realized that the cashpoint was too dominant, so I softened it. Next came the pale blouson, which I glazed over in the appropriate colour before turning my attention to the smaller man's grey trousers.

Stage 3: I painted in the faces of both men, making sure that I captured the slightly bemused look of the ambulance man, and opening the mouth of the smaller man a little more to give the impression that he is talking. I then worked on their hands and other details, such as the collecting box, afterwards further modifying the uniform and adding hatched strokes of red and green. The blouson's modelling was done using a pale pinkish colour, yellow ochre in the lighter areas and a darker blue-grey for the creases and shadow areas. I finished by putting a little more definition into the grey trousers.

RIGHT The Captive Audience; Tony Paul
Egg Tempera, 305 x 241 mm (12 x 9½ in)

PART FIVE
PORTRAITS

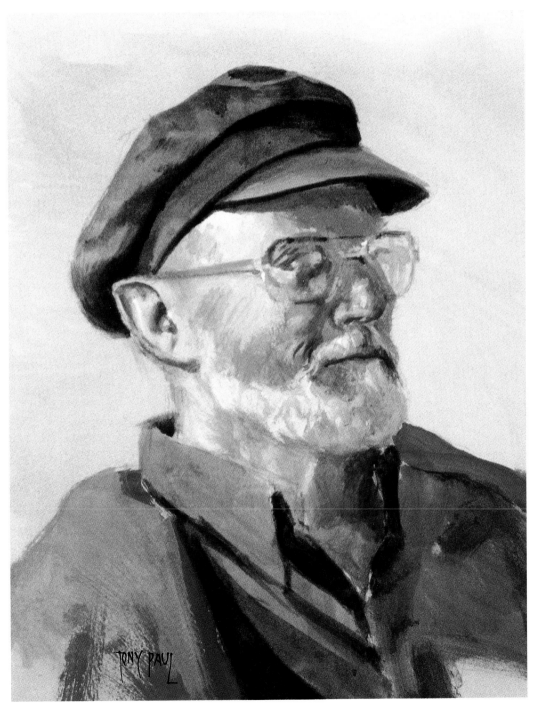

ABOVE Brian; Tony Paul
Acrylic, 559 x 381 mm (22 x 15 in)

THEIR PHOTO OR YOURS

It is quite likely that when you are asked to paint a portrait, you will be offered a photo to work from. Usually this photo will have been taken for the family album and before the shutter was pressed, the instruction 'smile please' will have been given. This is fine for the album, but these photos rarely make good paintings. Flash has been used, which reduces form, and the smile is just too broad. If you are wise you will ask to take your own, where you can arrange good lighting and create some kind of mood, perhaps like the two examples shown below.

CLOTHING

When we choose clothes, we select garments that will say something about us. So, what is worn by a sitter for a portrait is important, because it will act as an adjective for him. And without any other information about him, we tend to believe the image we see.

If, say, a Hell's Angel wanted his portrait painted, it would be incongruous if he turned up in a smart suit, just as it would be ridiculous to depict the chief executive of a large company in biker's leathers for a boardroom portrait, even if he spent much of his spare time riding his Harley.

Even when you try to get things right, you have to be careful. I was commissioned to paint a posthumous portrait of a chief executive. The painting was to hang in the company's oak-panelled boardroom. The company had no suitable photos and his family had dozens of him on holiday, but none of him dressed in a suit. I found a photo that I could use for his face and sketched him out, replacing his casual polo shirt with a suit and tie. I showed the sketch to the client, who gave the go ahead. When the painting was done, I invited the client to see it.

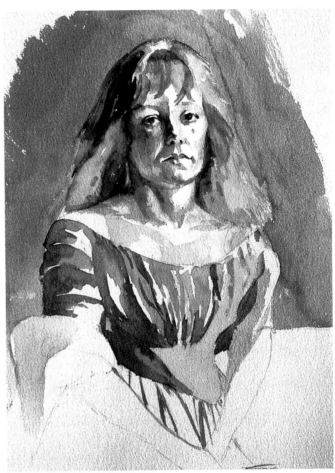

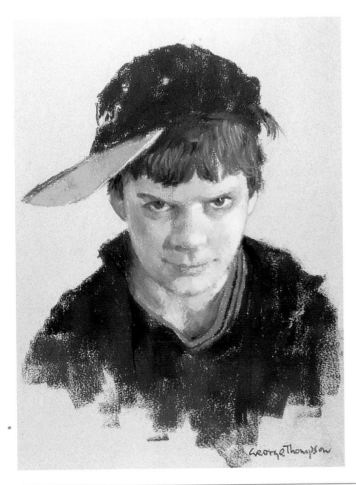

He agreed that the likeness was good, but there was something wrong – the chief executive was very conventional with suits and would only wear them in dark blue or black pinstripe cloth. The sitter had blue eyes, so I put him in a mid-blue grey suit that brought out the colour of his eyes. So, the blue grey simply wasn't him; he would never have worn such a colour.

It is best to discuss with the sitter (or the painting's commissioner) how he or she wants to be portrayed before the first shoot. This will then give pointers as to what clothes should be worn. But sometimes the sitter may wish to wear something that would look awkward or distracting in a painting, so it is best to ask to be shown a variety of outfits that the sitter would be happy with, so that you can choose one that will work well in the painting.

The cerise, silk ball gown worn by Niki (above) gives the portrait a formal look, while in George Thompson's portrait, Ryan's sardonic, typically teenage expression (left) is reinforced by the 'streetwise' look of the skewed baseball cap.

TRANSLATING PERSONALITY

One of a portrait's most important qualities is that it gives an idea of the kind of person the sitter is. The eye level of the camera can help with this. There are several clues in this photo of Bevis (right). The eye level is below his, so we literally look up to him. He, on the other hand, looks past us, and appears a little aloof perhaps.

His tie and jacket point to him being a businessman, his eyes are alert and sharp and he has the air of someone who is in control. The hint of a smile and the laughter lines suggest that he is an affable man and probably fair. This kind of pose would be ideal for the company boardroom.

In the photo of Jo (right), the eye level is the same as hers, making us equals. She is forthright and engages us with eye contact, as if she is interested in us and inviting us to engage in conversation. There is a suspicion of a smile to reassure us, but also, in that direct gaze and the slight jut of her jaw, an intimation that she would not put up with any nonsense.

In the photo of Dan (right), the eye level is higher than the top of his head. We are looking down on him. He looks up with an expression that implies that he feels threatened and unsure. There is also a hint that he may retaliate if threatened further. His serious expression reinforces the air of unease.

MOOD NOT MUG SHOT

Some photographic portraits can resemble the kind of image that can be found in police files and, while this 'matter of fact' hard style of portraiture can be effective, in painting a portrait we should try to say something about the sitter. I had long wanted to paint a portrait of John Lennon. He had an interesting face. I gathered together several photographic references of Lennon taken from all viewpoints and studied them carefully, doing little sketches from them. I began to be very familiar with the way the structure of his head worked and found that in my tempera painting I could get a likeness without using any of the references. The jut of his jaw to me expressed his self assurance, and the eyes captured his short-sightedness – he had a way of peering through his glasses.

I came to know Tony Gray, who modelled for portrait courses in West Norfolk, very well. He is a charming man but fairly complex, having led a full and interesting life. He had a vulnerable side, and I thought that I would like to show this in a simple head and shoulders portrait. I set the camera so that I was looking down on him. The strong side lighting helped to express his age, making a strong image, and I got him to look up at the camera in a slightly bemused way, as if unsure of how to react to us.

The watercolour painting made from the photo seems to capture what I was after. The image is quite strong for a watercolour, but I feel that the textures have worked well.

PORTRAIT IN PASTEL

I liked the pose adopted by Richard. Had he not rested his head against his hand, the pose may have been rather bland and, given his clothing, (which although perfectly right for his position as the bursar of a large college) a little too formal. So, we ended up with a semi-formal painting.

Stage 1: Having chosen a mid-grey pastel paper and turned it to use the smoother side, I began by drawing him in charcoal. Charcoal is ideal for beginning a painting. The mark is strong, yet much easier to rub out than pastel, so it is ideal when you are fumbling for a likeness. When the drawing was complete, I took up a creamy yellow pastel and put in the lightest areas. This immediately added a sense of form to the head. I followed this with the darks of his hair, beard and jacket. Surrounding his head with a green-grey background made the head stand out well. I couldn't resist putting in the red of his bow tie and hints of the white of his shirt.

Stage 2: I worked on the head, putting more colour in the hair, developed the ear to a fairly finished state, then turned my attention to the structure of the face. Cool caput mortuum was used for the shadows in the eye sockets and creases, while ochres and warm siennas were used for the fleshy parts of the face. Putting hands in a painting is a risky business. All too often they can appear as a bunch of sausages, so they need careful analysis. I made sure that the drawing of the hand was reasonably accurate – it is easy to make them too big, or more often, too small, so I was careful to check it against elements in the face. Then I blocked it in with a warm ochre. The final touch for this stage was to model the form of the forefinger and put in the creases of the forehead.

Stage 3: I revisited the head, developing the hair before refining the features further, strengthening the highlights and adding deep red touches to the eye socket, the corner of the nostril and the cheek edge. Up until now, the face had been painted only with ochres, creams and red earths. The brighter red gave the face coloration a little lift.

I worked into the beard, adding brown and refining its shape, then worked on the hand, putting a cool, pale purple into the shadowed side and adding highlights to the lit side. Although sketchy – as the whole painting is – it looks right.

I didn't feel that the bow tie was quite right, so I enlarged it, refined its shape and coloured it in, adding shadows with a purple and deep brown. Using a variety of greys, I worked in the forms of the shirt and then added lights to the shoulder and the sleeve of the jacket.

RIGHT Richard; Tony Paul
Pastel, 406 x 305 mm (16 x 12 in)

PORTRAIT IN OILS

The photo of Ayoade was taken after a session at my portrait class. She was photographed in natural light coming through the window. I would have liked more contrast between light and shade, but there were no blinds in the room and no darker corners. Sometimes you have to take things as they are and hope to change them to your satisfaction in the painting process. I liked the pose and the strong light on the side of her face and nose. The bright colours of her headscarf, earrings and dress worked well against the dark of her skin, but I felt that the multi-coloured stripes of the dress might be a problem. I decided to see how it went in the painting process.

Stage 1: I took an MDF panel that had been rough-primed with acrylic gesso and tinted it with thin raw umber oil paint. This was allowed to dry for a few days before painting began in earnest.

I started by drawing Ayoade carefully with a small round synthetic brush lightly loaded with dilute burnt sienna. When the outline drawing was complete, I scrubbed in the fringe of hair below her headscarf. I then went for the lights. The bright yellow headscarf was achieved by mixing cadmium yellow with flake white, and in the more orangey areas by adding cadmium yellow deep.

The strongest lights on her face were made with flake white with a little Naples yellow added. I was careful to ensure that these accents were applied accurately, adjusting the drawing as necessary. I then moved over to the shaded side of her face and applied some provisional darks, made with Indian red, ultramarine and a little Naples yellow. I indicated a few of the stripes on her dress.

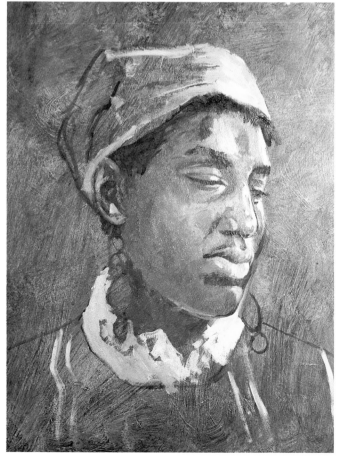

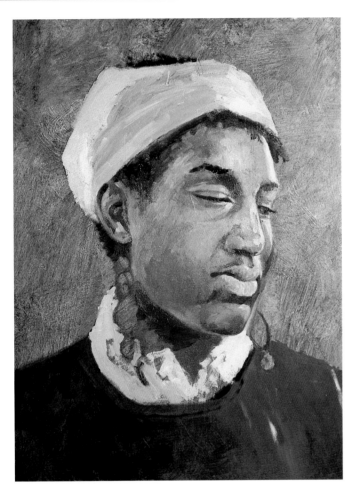

Stage 2: I began by working on Ayoade's face, bringing orange hints into the cheeks, chin and nose, and cooling the side of her face with bluish green. After roughing in the headscarf, I cooled the neck scarf on the shadow side by adding ultramarine. As a final touch in this stage, I started blocking in the dress. The strength and richness of this colour made the tones and colours in the face look insipid, and I began to wish that I'd blocked it in first, before doing much work on the face. I also felt that the plain burgundy colour was better and perhaps less distracting than the stripes, so I decided to keep things simple. Finally, in this stage I reinforced some of the drawing and the darker elements.

Stage 3: I reworked the face, refining, enriching and darkening the colours, while trying to keep them fairly bright. I worked in the cool, dully reflected light near her ear using green and cerulean, and streaked cadmium red and orange into the thick, wet paint of the headscarf. After working the creases and forms of the neck scarf, I painted her bright earrings in dense, opaque colour. Looking at the raw umber of the background, I felt that it was now too pale and decided to scumble a dark colour over all of the background. The paint was applied thinly, allowing hints of the original colour to show through, giving it a rich quality. This improved things greatly, and I went on to refine the detail of the lips, eyes, ear and nose. Finally, I reinforced the highlights on the nose, cheeks and eyes to give the portrait a little sparkle.

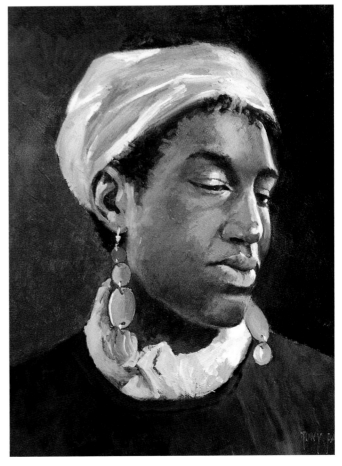

RIGHT Ayoade; Tony Paul
Oil, 305 x 241 mm (12 x 19½ in)

OTHER PORTRAIT SUBJECTS

I quite like profiles. This shot of my daughter Lynsey has almost a Pre-Raphaelite quality. I love the way the light shines through her red hair. The watercolour was begun by painting in the background. I could then work the tones of the head against it. The hair was painted using raw sienna, burnt sienna, green, crimson and vermilion hue, generally applied in flowing brushstrokes. I took care to ensure that the hair on the nearside of her face was slightly duller than that on the other side of her head, which has light shining through it. Her features were painted simply and with a light touch, leaving a lot of white paper. The eye was just suggested behind its curtain of hair.

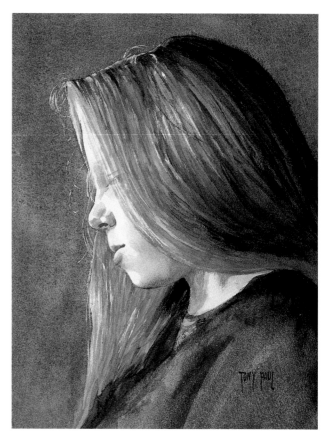

A much younger Lynsey, this time in "One M or Two?" I set up the pose in my studio, hanging a dark blanket behind her and using the natural light from the window. I used black and white film and had her in the studio with me when I painted the portrait so that I could get the colours right (I never trust Kodak, Fuji or Agfa to get it right every time). Her complexion was so subtly-creamy with cool purplish shadows that had I used colour film, she would probably have come out with a Mediterranean tan and brown hair.

PART SIX
ANIMALS

ABOVE A Walk in the Mist; Jonathan Newey
Watercolour, 279 x 203 mm (11 x 8 in)

TIGER

It is quite difficult to find good copyright-free references for wildlife subjects such as big cats, unless of course you are a seasoned safari goer with a good camera and very long telephoto lenses.

Probably the best bet is to find the nearest zoo and pay it a visit. It wouldn't hurt to give the zoo a ring first to check when the animals you wish to photograph are at their liveliest and out in the open air, where you can photograph them. (There is a limited appeal for paintings of sleeping lions, and it would be a wasted journey if they did their sleeping in their lion house.)

Jonathan Newey visited his local zoo and took suitable reference shots for the watercolour shown on the previous page. A little ingenious imagination can transform this caged animal, sullenly stomping about in his obvious zoo setting, into a free spirit, absolutely in control of his own destiny.

The photograph of woods was from a totally different place. Jonathan has used the photo as a rough guide and created a snow scene within which to set the regal tiger. Background trees are ghosted out and spectral birds fly in the distance. The painting is broadly in complementary colours – purple and yellow – the limited colour scheme giving unity to the painting. The trees and background have been greatly simplified, with the tiger being brought out in sharp focus.

THE FARM

The slanting rays of the sun lit up the fields and trees near the village of Lower Kingcombe in Dorset. Often there are cattle grazing in these fields, and I was hopeful of finding a ready-made subject. Although the landscape element was good, encouraging me to take several shots, I only found one animal, almost in silhouette and in the distance.

I felt that I wanted more animals in the painting and found some in a near-by field. I liked the arrangement of the young cattle and their colours in the light, so I approached quietly and took the photo quickly, just before one of them spooked the others and they all clomped off to the security of the trees. I went home with the shots I had taken and chose the best landscape shot (which, coincidentally, was the one with the distant cow) and decided to marry that with the shot of the cattle.

I decided to do the painting in acrylic and used a board, rough primed with acrylic gesso and toned with a wash of raw umber. As is my usual practice, I started with a tonal drawing as the first stage of the painting. I drew the animals roughly in their positions and blocked in the tones. This gave me a good idea of how the combined subjects would work. I then mapped in the sky.

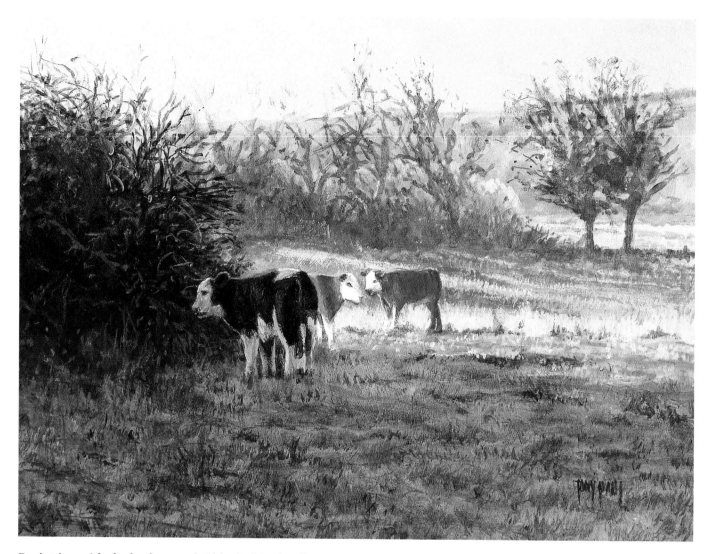

Beginning with the background, I blocked in the distant fields, creating a slightly misty look by adding some of the sky colour to the hills. I worked forwards, trying to keep the bright, sunlit feel, enjoying the contrasting colours and textures of the dry and lush grasses, the scrubby trees and the bushes. Acrylic, by its nature a translucent medium, will make opaquely thick and transparently thin elements in a single brushstroke. This, combined with its speed of drying and consequent ease of overlaying, make it excel in textural work.

I worked the painting up in several layers applied loosely – it would be all too easy to drift into fiddly detail, which I didn't want to do. The cattle in the light had an almost orange glow and their muzzles were white, so I gave them a light touch, keeping the colours rich, with no strong tones. The cow in the foreground,

ABOVE Cattle at Kingcombe; Tony Paul
Acrylic, 305 x 406 mm (12 x 16 in)

being in shadow, was much darker, its white markings becoming a dull purple in the subdued light.

I did allow myself a thin line of white on the top of its head and a line of orange around the contour of its ear and along the ridge of its back. This helped to pull it forward, away from the dark bush. I felt that the foreground shaded green was a little too acid, so I added some light mauve to it to neutralize its effect a little.

I still feel that the composition of this painting is not as good as it might be. I feel that if I added another cow in the right foreground, facing into the picture, it would improve things by balancing the composition a little better. Oh well, where's my sketch book and camera?!

GARDEN BIRDS

Garden birds such as the blue tits shown are a constant joy to watch. They are a great subject for a painting, too, but are reluctant to stay still for more than a second. This makes sketching difficult, but in a sixtieth of a second the camera can give us all the information we need.

With birds, it is best to focus in on the subject and just fire away several shots in close succession. I use reflex cameras so, at the moment of exposure, I don't actually see what I am getting because the mirror in the camera flips up to expose the image, so multiple shots are the best idea.

I took three shots of blue tits on a peanut feeder and in each shot only one bird's head could be seen. As much of the character of an individual bird comes through in its head, 'decapitated' birds are not an option! So I combined the photos of the tits into one painting.

Bird painters sometimes lose the plot a little, concentrating so hard on the colours and variations of the bird's plumage in its smallest detail that the painting becomes a map of the bird – as if the solid, breathing creature had been removed, leaving the immaculate plumage ironed flat. At all costs, I wanted to give the impression of living, active birds that could fly away at any second. The plumage detail would be there but it would not be the overriding concern.

ABOVE On the Nuts; Tony Paul
Watercolour, 355 x 255 mm (14 x 10 in)

My first consideration was to mask off the feeder and birds with masking fluid, being careful to cover the bird shapes completely. I then painted a large wet-on-wet wash implying distant foliage. Next, I had to create a feeling of light falling on the birds to give them a sense of solidity. I was careful to apply tonal washes of the appropriate colour and, when this was done, the shapes, even without feather details, read as solid birds.

ABOVE On the Nuts; Tony Paul
Watercolour, 355 x 255 mm (14 x 10 in)

The feeder and its nuts were carefully worked, taking clues on how to represent various textures and forms from the photos. Lastly, I turned my attention to the birds, developing the colours and forms of the plumage as I went.

PART SEVEN
HISTORICAL SUBJECTS

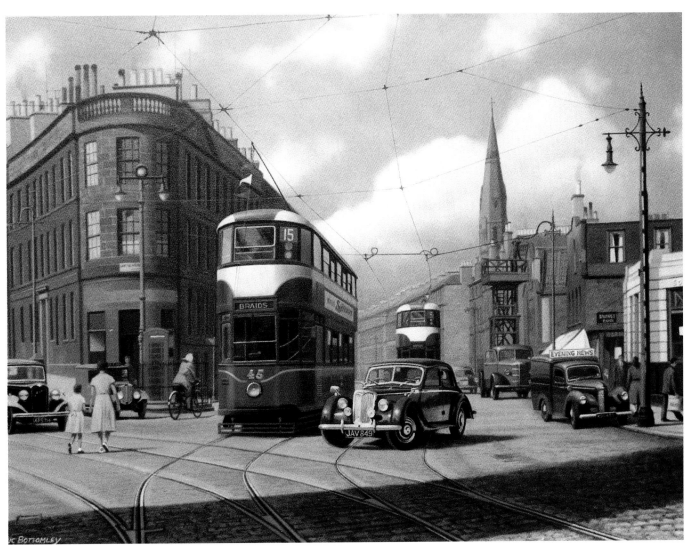

ABOVE Abbeyhill, Edinburgh; Eric Bottomley
Oil, 508 x 762 mm (20 x 30 in)

A COMPLICATED SUBJECT

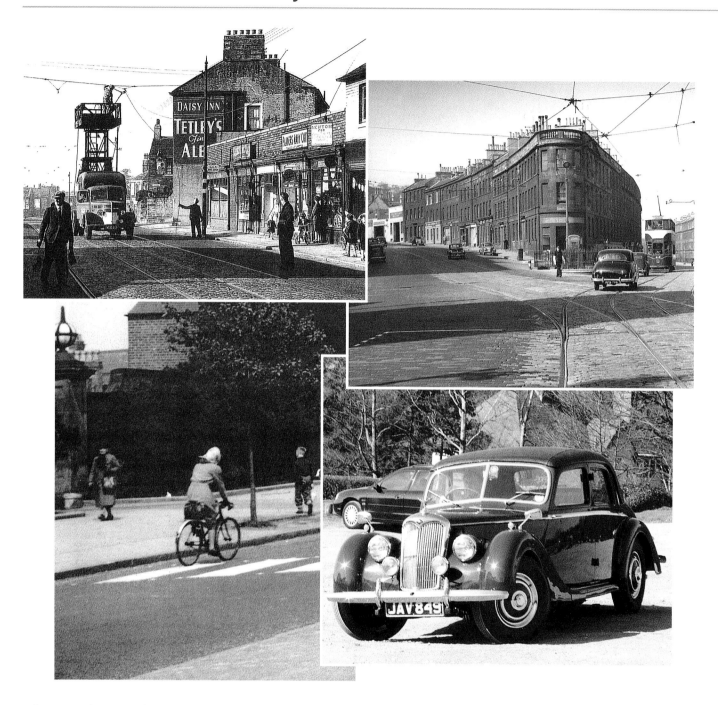

Eric Bottomley specializes in historic scenes such as the one illustrated on the previous page. The use of photographs is often essential, as many landmarks shown in his paintings have either been demolished to make way for more modern developments, or have been so altered as to bear little resemblance to their appearance in times gone by. Paintings such as this are important in distilling an era in a town or city's past.

Eric never relies on one reference, preferring to build his paintings from several sources from the same period. He makes sure that the perspective of each is compatible with the others and arranges them to form an interesting composition. In total, nine references were used for the painting of Abbeyhill, Edinburgh, four of which are reproduced above.

The painting is set in the 1950s, and Eric is careful that all the vehicles and people's clothes are true to period. Subjects such as this are popular with transport buffs, who are quick to point out any small inaccuracies, so research is all important. Eric has a large collection of books, photographs and magazines to ensure that it all works as it should.

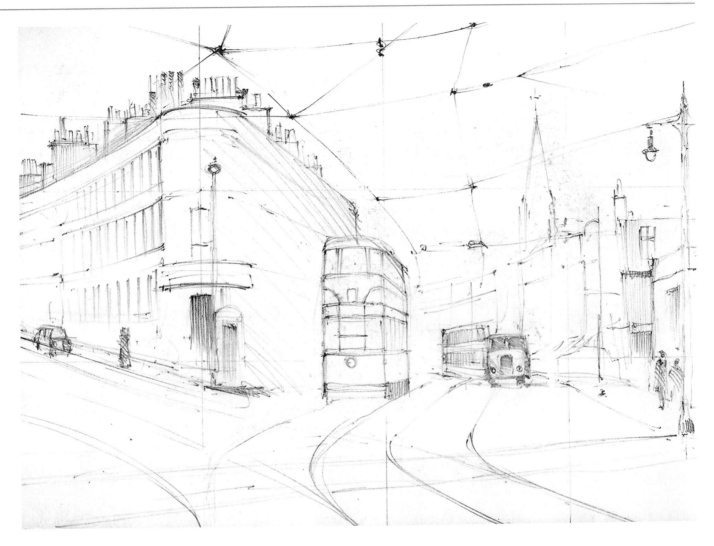

The composition is arranged in the drawing stage, and the background buildings are placed comfortably. In this case, the photo of Abbeyhill was cropped – a quarter off the bottom and a quarter from the left, with a small amount cropped from the right side.

In this first half-scale sketch, the cropped composition is established, and Eric has begun to leave out or move certain elements and add to the composition. As it stood, he felt that the scene lacked activity – the tram, the main focus of the composition, was too far away and he didn't like the tail ends of the two cars being in the foreground. When he moved the tram closer to the corner of the building, he felt that there was nothing between this and the lorry, and so he sketched in another tram and added some smaller figures and a car up on the hill to the left. As a preliminary sketch, he felt that it could work but still needed more elements to be added.

Looking at the sketch, he noted that the interest was evenly stretched in fairly isolated bits across the scene. The car up the hill was too tiny and so far away from everything else that it drew the eye. He squared up the drawing on a 20 x 30-inch sheet of tracing paper and carefully traced the subject onto a white linen canvas. While tracing, he enlarged the tram further, bringing it forward, having felt that the building still dominated it. He was not overly happy with the directly frontal view of the lorry, but put it in, thinking to exchange it for something more interesting later.

Stage 1: The sky went in first, then the elements of the building were blocked in and the tram added. At this point, Eric could see that much more interest was needed in the area of the corner of the building, so straight away he selected a black Austin car, a red van and three figures. The figures were small, incidental parts of other photographs, but absolutely right for the painting, so in they went. These additions were worked up to a fairly high degree of detail. He then began blocking in the buildings on the other side of the road, but stopped to review what would be best to put on this side.

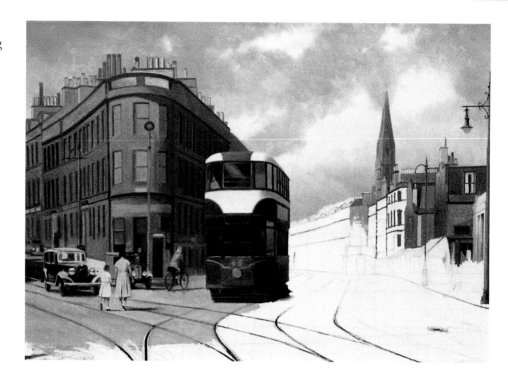

Stage 2: In the background, the front view of the lorry was omitted and the more interesting tower lorry inserted in its place, but more to the right. A second tram, further back, stopped the ancillary vehicles being too much of one height. To complete the foreground, a newspaper van and the Riley car, crossing the path of the tram, completed the transport, while three additional figures populated the pavement. Again, these elements were brought to a high level of finish. Eric put in more work on the sky and the left-hand buildings, adding the detail of the balustrade and the street lamps.

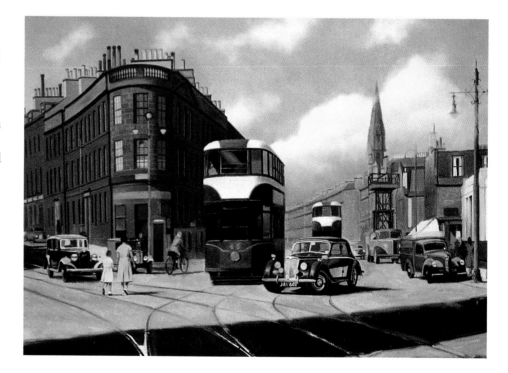

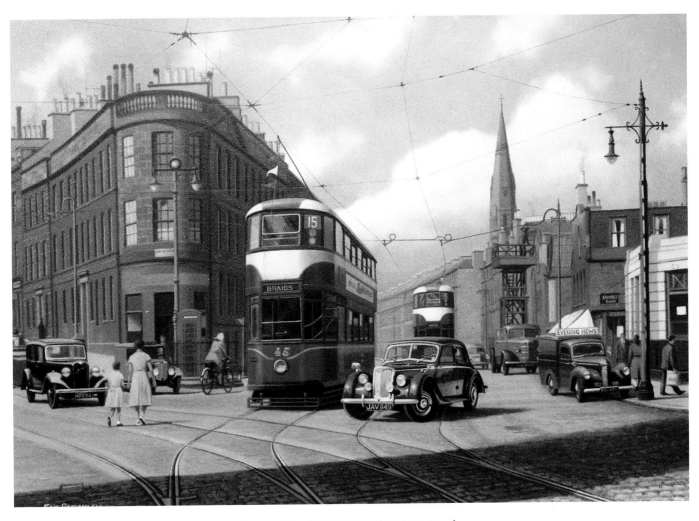

ABOVE Abbeyhill, Edinburgh; Eric Bottomley
Oil, 508 x 762 mm (20 x 30 in)

Stage 3: The final stage was one of refining. Eric worked on the church spire and changed the colour of the tower lorry to make it more prominent, before turning his attention to the white building on the right, indicating the banding of the walls.

Feeling that the main building was too dark, he lightened it and added detail to the stonework. His attention then turned to the cobbled street, the right-hand lamp post and the tram rails, which he brought to a high degree of finish. The overhead power wires were carefully put in place before Eric finally began working on the trams, softening the colours back a little and adding the detail.

In this painting, there is a strong flavour of its time. The clothes – particularly the women's, and the cars and lorries tell us a lot about the 1950s. Most of the motor vehicles are commercial transport. Only the Riley and the Austin are personal transport. In the post-war years, only a minority of people owned cars. The rest travelled by bus, motorcycled, rode a bicycle or walked. If Eric painted the same view today, no doubt it would be choked by grid-locked traffic.

This painting was to be for the cover of a novel about 19th-century stowaways. I had to create a painting that would stand on its own, yet still work when lettering was added.

I did a few sketches to get the feel of the subject. You have to be sensitive to the story by creating an interesting cover that doesn't give the plot away too much. I chose to illustrate a passage where the stowaways were put on to the ice floes off Newfoundland. I did quite a lot of research on the ship, even finding out its international identification signal flags, and visited the Cutty Sark, taking lots of photos. The Cutty Sark was a lean racehorse compared to the dumpy merchant-man, so I followed my research more than I did the photos. However, the latter did give me a good feel of how a sailing ship looked.

I collected references of ice floes, adapting and honing them to create the conditions that were written about. I felt that the appropriate medium for the painting was oil. Its buttery quality would work well in the portrayal of the ice. The figures were based on shots taken in a local town, but painted in Victorian clothes.

ABOVE The Arran in the Ice; Tony Paul
Oil, 406 x 305 mm (16 x 12 in)

DOCKSIDE SCENE

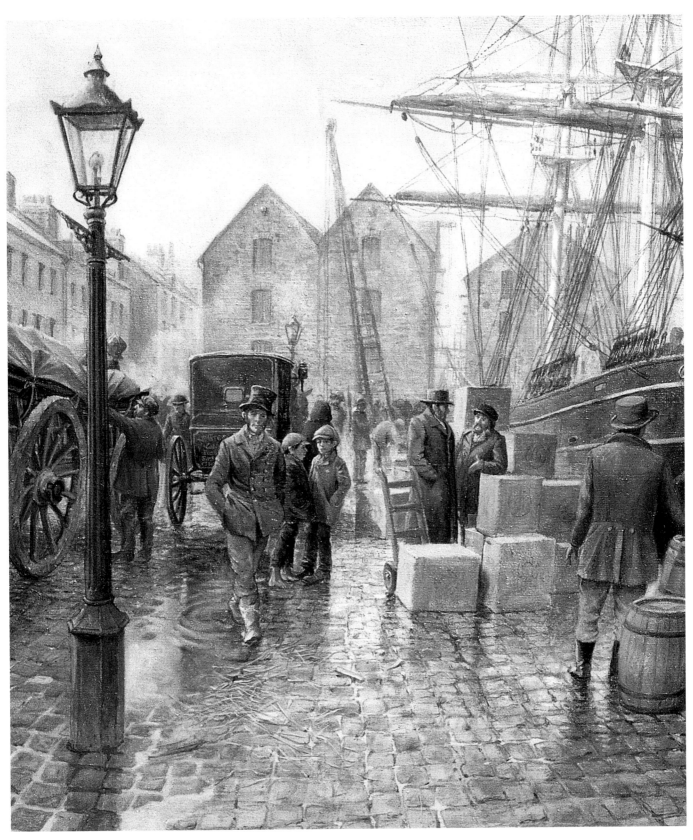

ABOVE Victoria Harbour, Greenock, (detail); Tony Paul
Oil, 609 x 914 mm (24 x 36 in)

Courtesy Watt Library, Greenock

The painting on page 99 was to be done as an illustration for the previously mentioned book about some backstreet Scottish boys who stowed away to Canada in 1868. The photographs of the costumed figures were taken of extras during a break from the filming of a TV period drama. The pencil sketch of the Scottish port of Greenock in the mid 1800s was taken from the book *Sketches of Greenock* in 1886 by Cathcart W Methuen. The quayside and ship wouldn't have changed much, if at all, from the target date of 1868. I checked this sketch against large-scale contemporary maps of 1868 and found that the warehouse buildings were as shown. It was interesting to see the crane, bollards, streetlamp, ship and figure, and the indication of the cobbles of the quayside. They gave me a stage on which I could create a tableau of the bustling commercial port that Greenock was at the time.

I also researched merchant ships of that era and took great care with their representation, particularly with regard to the masts, yards and rigging. I decided to use a similar view to the Methuen drawing, but closer in, to show the area to the left of the quayside. I could tell from reading about Greenock (yes, a lot of research is necessary to get things right) that there were terraces of tall buildings parallel to the quay – too far to the left to be included in Methuen's drawing. My map showed me where to place them, and I made sure the perspective was in accord with other elements of the painting.

Sketch drawing

The Methuen drawing was observed from a higher viewpoint with the eye level near the top of the lamp-post. The figures in the photos were all viewed from the eye level of a standing person – see how the heads are more or less on the same level. Clearly, the two were incompatible. I didn't want a high viewpoint anyway, so I brought the eye level down to be consistent with that of the figures. The painting had to feature two small boys – a couple of the stowaways. I had no references for these so I made them up, as I did some of the lesser figures. I sketched in the basic setting and placed the figures carefully, adjusting their size according to their place in the setting, keeping most of the heads at about the same level and on the viewer's eye level. I placed the two stowaways behind the principal figure, as I didn't want them to be overly prominent. Along the way there was a bit of rubbing out where I changed my mind, but generally the scene came together fairly quickly.

Stage 1: I worked from the back to the front of the painting. Greenock at the time was a very dirty, grey town, so I kept the colours to off greys. I began with a neutrally coloured sky and in front of this blocked in the shapes of the terrace of buildings on the left, the blue carriage, the tall warehouses in the centre and the solid bulk of the ships on the right. I also ghosted in the figures in their allocated positions. Following this I worked on the buildings, developing them to a reasonable degree of finish.

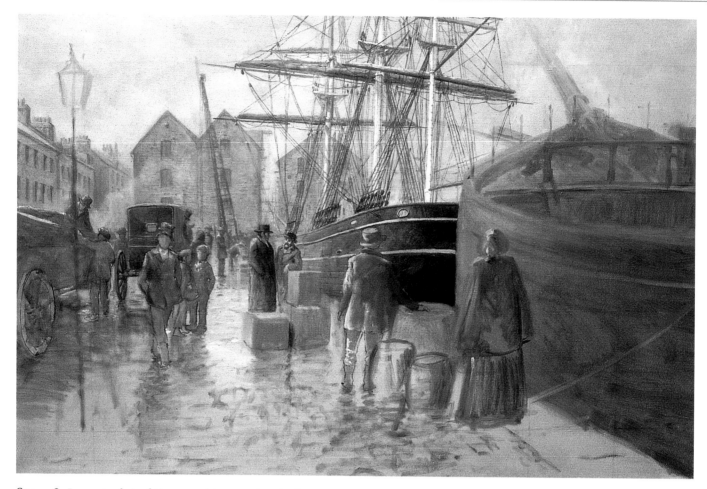

Stage 2: I spent a lot of time working on the rigging, masts and yards of the main ship in the centre of the painting. As reference, I used accurate models and authoritative rigging plans of merchant ships of the period. As the whole mass of the rigging would become terribly confused, I tackled one mast at a time.

After this, resolving the carriage and the two characters by the boxes, and roughing in the remainder of the figures and the wagon were fairly easy, but I did have to be careful to get the spokes of the wheel of the carriage looking right. A final touch was to ghost in the lamppost and the wet reflections of the figures and the boxes.

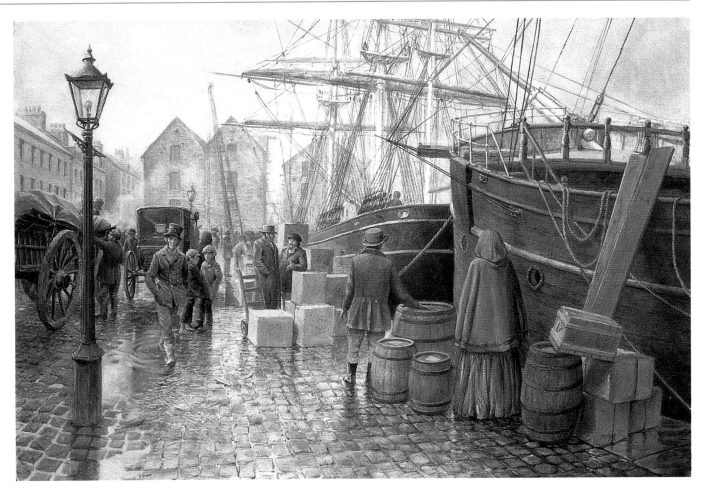

Stage 3: I worked on the middle-ground figures and firmed up the wagon, again working hard to get the wheel spokes right. The lamppost, based on Methuen's drawing, went in, followed by the cobbles, puddles and strewn debris. I had no references for this and so was working rather more by instinct and memory rather than any pre-conceived plan. The foreground ship went in next with the barrels, boxes, planks and figures carefully resolved. When the work was complete, I went over the painting, reinforcing weak areas and softening elements that were overly prominent.

I wanted to create an impression of a busy dock and include the two principal characters – the boys who later stowed away – fairly prominently among the various people on the quay. These were painted from descriptions in the book.

ABOVE Victorian Harbour, Greenock; Tony Paul
Oil, 609 x 914 mm (24 x 36 in)

RURAL SCENE IN OILS

I love the social realist paintings by artists such as Millet, Breton, Lhermitte and Clausen, and when my wife bought a garden statue that may well have been inspired by a figure in Millet's "The Angelus", I thought that someday I might use the statue as a basis for a painting.

Using a photograph of a wheatfield in my village (with my wife to give scale and lighting) and a photo of the statue, I decided that this book gave me a golden opportunity to paint my own version. I set the statue up so that my eye level would be correct – roughly level with the bottom of her rolled-up shirt sleeve. I did a largely tonal drawing to see if the subject would work, adding in stooks of wheat, a peasant with his scythe and two more women in the distance. I posed them all as if in prayer.

Stage 1: Using an oil-primed linen canvas tinted to a honey colour, I mapped in the subject with a blend of Venetian red and cobalt green. The drawing of the figure was carefully done. I added the lower part of the sky in white so I could see how the head of the figure would stand out against it and added the spire of a church (the Angelus bell was sounded at sunset to remind the Catholics to say the devotion). I hoped that the rough application of paint in the hedgerow and in the stubble of the wheatfield would serve as a good base on which to build the appropriate textures.

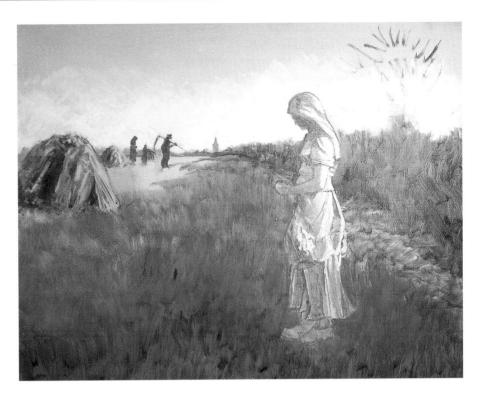

Stage 2: I began the colour work with the sky, gradating the purplish grey down and blending in cadmium yellow and white. The distant landscape and church were painted in the darker sky colour. I referred to the landscape photo to get the sunset's light on the field and extended the wheat stubble to the bottom of the painting. Then the wheat stooks went in, with dull purple used in the shadows (a tip I'd learnt from Monet's haystack series). The stubble in the shadowed areas and the hedge needed darkening, so I drew broken darks in burnt umber, cobalt green and dull violet, picking up on the textures suggested in the underpainting. The colours of the figure were then mapped in and, to my relief, the statue stopped looking like a statue.

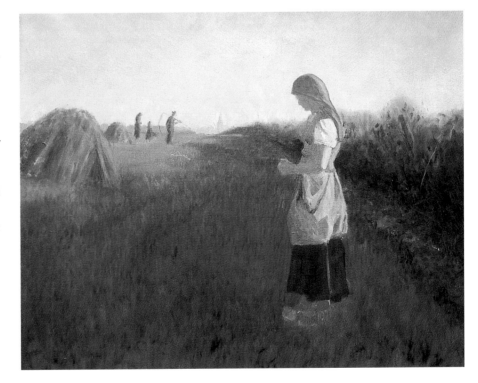

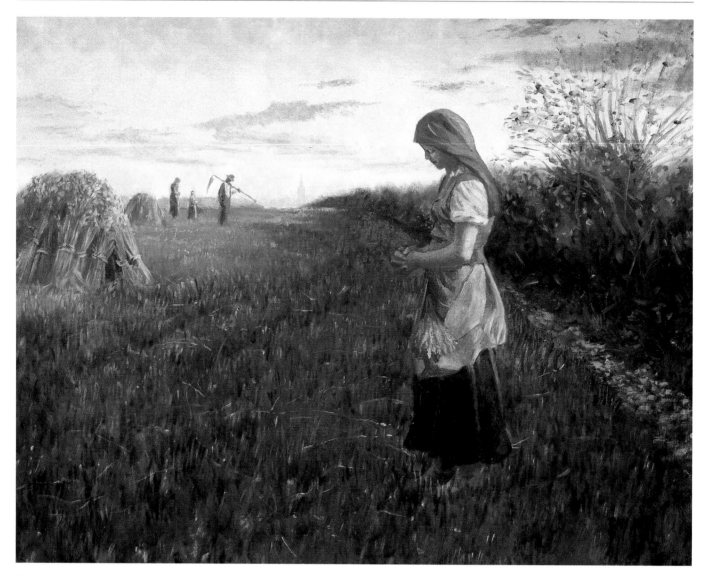

Stage 2: In this final stage, it was a matter of pulling things together. I added the clouds with dry purplish paint applied with a soft-haired brush, then reworked and put detail into the distant figures. I then added texture to the sunlit wheatfield and detail to the stooks, using the lower sky colour for the light touches. The hedge needed work, so I added the taller bush and punctuated the hedge with penetrating light and bits of dull green foliage. I then added flints to the footpath.

In modelling the figure, I was careful to keep the sense of light on her. I didn't want her to be too colourful, so other than her headscarf all the colours are neutrals.

ABOVE The Angelus; Tony Paul
Oil, 406 x 508 mm (16 x 20 in)

The thicker white paint of her blouse sleeve was still wet, so I delayed giving her a final golden glow until the paint was dry. I used cadmium yellow deep mixed with painting medium to create the golden effect of the sun. This was scumbled over the lit areas of her body to give an overall cast of colour. The final touch was to take a fine brush to define the stubble with occasional light specks and draw fine wheat stalks in the stubble.

TECHNICAL SUBJECTS (BEWARE OF THE RIVET COUNTERS!)

Bygone subjects such as steam locomotives, cars, aircraft, ships or historical battles are potential minefields for the artist. There is plenty of information available on all these subjects in the form of books and magazines. These tend to attract almost obsessive enthusiasts who will develop expert knowledge in their fields and expect every detail in a painting of a certain subject to be totally correct. The title "rivet counters" is from certain railway enthusiasts who will count the rivets along the boiler of a locomotive in a painting and chastise the artist if there is one too many or one too few, often dismissing the painting as inaccurate. However, enthusiasts such as these provide a consistent and dedicated market for painters who depict their specialized subjects. They expect the paintings to show great detail, so the artist really has to have a depth of knowledge at least as good as that of his potential purchasers.

The painting to the right shows fitters servicing the Merlin engine of a Spitfire. Mike Gunnell took the reference photo and is also an enthusiast of historic military aircraft. His painting is accurate in every detail, yet looks fresh and is handled with a painterly touch.

ABOVE Servicing the Caroline Grace Spitfire; Mike Gunnell Watercolour/Gouache, 406 x 508 mm (15 x 11 in)

ABOVE Marshal Ney at Waterloo; Tony Paul
Oil, 601 x 904 mm (24 x 36 in)

I now have to put my hand up to being a bit of an "anorak" myself, at one time having studied in depth the battles, uniforms, arms and accoutrements of the Napoleonic era. Thus I was able to recreate battle scenes such as "Marshal Ney at Waterloo" – he is the red haired hatless chap in the foreground.

For my research, I scoured newspapers and magazines for photographs of horses in motion, especially prizing those falling or fallen, cut them out and pasted them in a scrapbook for easy reference. I also studied the sequential photographs of galloping horses taken by Eadweard Muybridge, so that I would get their legs right – no more rocking-horse poses. The horses in the painting were all adapted from my scrapbook. The figures, shown galloping their exhausted mounts across the right terrain, are made up, but are wearing the correct uniforms of the right regiments. I even visited the battlefield and took photographs at points of particular interest, so any paintings including them would be accurate. How sad is that!

My interests extended to marine subjects of the same period. Again I studied in depth, made models from kits, read books, viewed historical movies, researched the rigging, made studies of the sea in all its moods, and watched and photographed visiting historic, square-rigged ships sailing out of harbour at Poole, in Dorset. All these references were absorbed and relevant ones put together, initially in a pencil sketch to try out the idea, then worked up into the oil painting "Coastal Patrol".

ABOVE Coastal Patrol; Tony Paul
Oil, 406 x 305 mm (16 x 12 in)

PART EIGHT
A STYLISTIC APPROACH

ABOVE The Jogger (detail); Lisa Graa Jensen
Acrylic/Ink, 267 x 267 mm (10¹/₂ x 10¹/₂ in)

BEACH SCENE IN ACRYLIC INKS

A favourite holiday venue for Lisa Graa Jensen is the French seaside area called the Côte d'Opale. The place bustles with life, healthy sports, sun and sea.

In no sense are the photographs copied; they are as much memory-joggers, as information. In a way, Lisa's painting is a condensation of the place, much like the old circus posters I used to see as a child, where everything was shown happening at once.

Sketch drawing

Inspiration can strike at any time – often when there is no sketch pad or paints handy. Lisa sketched her idea out in biro on the back of an envelope. It is no less valid for that. The sketch is lively and full of action. Curved lines give a good feeling of movement, and the horses and dogs have the same kind of elegant simplification,

exaggeration and character as the animals depicted in cave paintings.

Because they draw on the love and understanding of the subject, paintings such as this have a far greater visual and emotional appeal than overtly literal works would have.

Stage 1: The drawing was sketched down fairly firmly onto paper so that it would show through the overlaid colour, then the main elements were blocked in. The sky was developed to a finished state, but the rest was painted as an underlayer. Already, we can see the rhythms suggested in the drawing becoming more pronounced and giving personality to the work. The purity of the colours suggests bright sun. The colours and tones of the beach create the impression of undulations. Texture is an important element in Lisa's work: we can see dry-brush, wet-on-wet, scumbled and dotted textures already in place.

Stage 2: Having established the basic structures and forms in the painting, Lisa now concentrated on developing the painting to a finish. The darkening of the foot of the cliffs gave them more form and cleaned the edge between sand and cliffs. Next she spotted in yellow to give texture to the crest of the main hump of the beach. Similar treatment was given to all but the extreme right-hand part of the beach. The forms are now sharper, with a strong linear character. White ink and opaque turquoise and blue detail was added to the sea to create breeze-fuelled movement and most of the figures and animals were carefully painted in position.

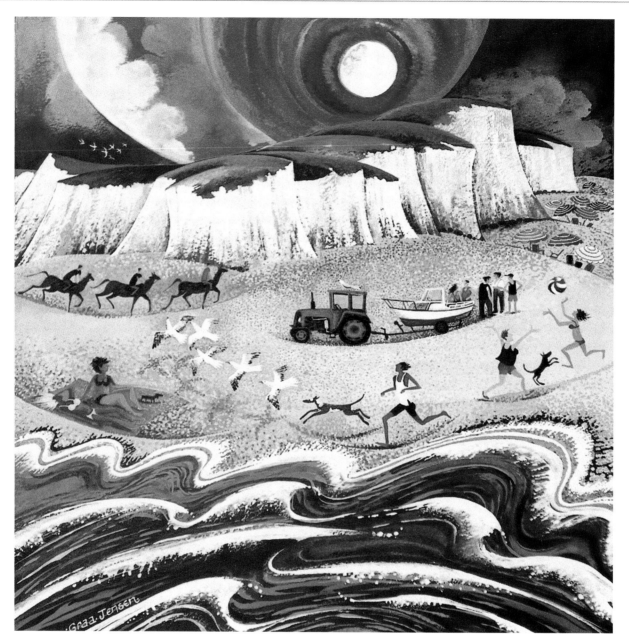

Stage 3: Once the remaining elements were put in, Lisa could evaluate the progress of the painting. Perhaps the cliffs needed a little more work; are the bases of the cliffs too dark, the sunbather's towel too pale, the running dog too black? Extra figures were put by the boat, and the receding sunshades and beaches on the right were painted in and brought to a good finish. Perhaps Lisa felt that the strong change of tone in the area where the gulls would go was confusing, so parts of it were softened and the gulls and their shadows painted over the top. The textures of the beach were enhanced with more dotted work and, as a final touch, white birds were put in the sky over the cliffs.

ABOVE The Jogger, Lisa Graa Jensen
Acrylic/Ink, 267 x 267 mm (10½ x 10½ in)

With this demonstration, we can see just how an artist begins by blocking things in – a rough and tentative base, continues by working up the image, and then, as the painting grows, re-assesses and makes changes as necessary. It is important that the artist is sensitive to the needs of the evolving painting and has the courage to change things, sometimes in a major way. Nothing should be set in stone. In the end, the painting has to work as a whole. It is interesting to see the process of continual evaluation and refinement being applied so well.

TOPIARY GARDEN IN ACRYLIC

I saw these two larger-than-life characters in a public garden and quickly took a photograph of them. The gardens looked good, and the couple was framed comfortably within the greenery, but I felt that perhaps it would be better if the garden was a little eccentric. There was something about the couple that made me think of Alice in Wonderland – and in terms of a garden, Alice in Wonderland made me think of topiary trees. So I planned them in.

 Before beginning the painting, I did a rapid sketch in pencil on cartridge paper to try out my ideas. I liked the foreground bushes and the background pines but altered the rest, putting in topiary trees and steps instead of the gravel and railway sleepers. I made the figures squatter and brought them forward a little. I felt that the figures and their environment were now more in keeping.

Stage 1: I took a watercolour board and began working on the background. I started with the sky, painting it in a broken way, first with a pale pink, then pale green, pale, warm yellow and finally pale blue. These colours were all much of the same tone, so they blend in the eye to give an overall warm blue effect.

Using soft green, I mapped in the background trees and wall, then the more acidic colour of the lawn. I had no worries about the patchiness of the paint. Acrylic is fairly translucent when applied thinly, and I always welcome the opportunity to exploit 'happy accidents' when I come to overpaint.

Leaving the figures and the topiary trees as white paper, I put in the foreground bushes fairly darkly, in a mix of phthalo green and burnt umber, knowing that I would be overpainting later with lighter colours. The steps at this stage were just brushed in with single strokes of grey.

Stage 2: I decided now that I would develop the painting in quite a detailed way in an egg tempera technique that involved using small touches of juxtaposed colours. I began in the background, building up the colour and tone of the trees with dull and bright greens, and smoky purples, creating a feeling of distance. I didn't want the scene to be too claustrophobic. Next to go in was the wall, with every brick shown. I then tackled the lawn, drawing with the paint in short, vertical strokes.

The topiary trees were painted in sharp focus, the dotty technique working well in describing the tight texture of the small leaves. I put the steps in and added a shadow cast by the right-hand bush and finished this stage off by thinly washing in the colours of the figures.

Stage 3: Working light over dark is a great advantage. Painting this bush in watercolour – and having to paint in darks for all the negative shapes – would be a night-mare. Somehow this often looks clumsy.

The leaves were, nevertheless, quite tricky. I used warmer, as well as lighter, colours where the foliage was in the light and cooler, lower toned colours in the shadowed areas. I didn't copy the foliage but summarized it, based on observation of the character of the plant.

I like the difference in personality of the evergreen on the right but portrayed it in a similar way, keeping the shaded areas cool and the sunlit ones warmer. I then added a shadow across the bottom of the painting.

ABOVE In the Topiary Garden, Tony Paul
Acrylic, 305 x 229 mm (12 x 9 in)

This is a commonly used landscape ploy, tending to give a painting a sort of threshold, before entering the painting proper.

Finally I moved on to the figures. I had left them until last so that I could ensure that they worked against the background. Acrylic paint, as I have suggested, is naturally textural and it works very well for detail, too. I enjoyed working up the figures with thin touches of paint, carefully bringing out the forms with subtle tonal work.

Boatyards are terrific places for painters, full of texture, colour and dynamic shapes. I took this photo at Poole many years ago when flat caps, rather than baseball caps, were the order of the day. I had often thought of making a painting from it but had never got around to it.

Upon seeing Roland Batchelor's wonderful watercolour "Tea Break, Richmond", I was inspired to paint my own, very different, version. The figures in my photo are very small and one is almost hidden, so I imagined my viewpoint to be closer to the figures, as if viewed from between the boats. I decided to do a pen and wash, but began with a light pencil drawing. I couldn't see the figures clearly so largely made them up, giving them very different characters, and sat them on an upturned, flat-bottomed boat. I applied transparent watercolour washes, later reinforcing them with black pen.

BELOW *Tea Break at the Boatyard*; Tony Paul
Pen and Wash, 229 x 229 mm (9 x 9 in)

Painting abstracts from photographs

Above Cheselbourne 2; Tony Paul
Acrylic, 254 x 216 mm (10 x 8½ in)

ABSTRACT IN ACRYLIC

Although some abstract art is totally invented, with no reference to anything, just made by pushing paint about and following natural instincts, much of what we know as abstract art is rooted in reality. This reality is then synthesized into an image that is not overtly representational.

Arguably, abstract art is the purest of all art forms because it stands as itself – a painting, an emotional response to colour, form and texture, rather than as a vehicle to represent something, or to tell a story. Photography can easily provide a foundation for an abstract, such as my painting "Cheselbourne 2".

Stage 1: The photograph is as a close-up of a battered, red and white bollard in a dock area of La Romana in the Dominican Republic. I loved the texture and felt it would make a good abstract painting.

When we moved to our village amongst rolling countryside, I was suddenly aware of field edges against the sky: the broken line of a hedgerow, wind-blasted trees, posts and fences. When I looked at the photo, it reminded me of my new environment.

Using a panel primed with acrylic gesso into which sand had been mixed, I began by scrubbing a layer of thin, dull bluish purple all over the panel, then dabbing some of it off with kitchen roll. Using thicker paint, I overlaid most of this with a lighter colour based on crimson.

Stage 2: At the right-hand side and bottom of the painting, I added the very dark purplish elements before painting in the white band at the top with broken paint, dragging some of the white down into the red and working the residue into the lower part of the painting. The rough surface of the panel, although hard on the brushes, made a broken, crumbly texture easy to achieve – the acrylic paint, applied thickly now, working in a predictable way.

Stage 3: I felt that the white in the lower part of the painting was too large in area and too bright, so I softened it with very thin glazes of purple grey. Although I was reasonably happy with the textures and colours painted so far, I wanted to add more and perhaps create a lighter colour nearer to the border with the white. First, I added touches of cadmium red, working the colour into 'happy accidents', then made a cool pink and placed it here and there. The whole painting was hot in colour, and I felt that a touch or two of cooler hues might be of benefit, so I added hints of pale green and blue in the dark area and touched diluted colour into the dark shapes above and to the side. Finally, I dabbed small dashes of ochre into the top of the red area.

ABSTRACT IN ACRYLIC

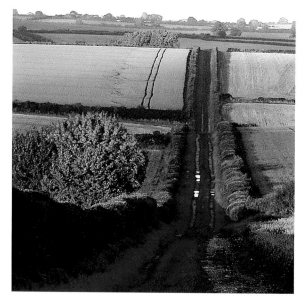

With "Cheselbourne 1", I took the abstract shapes of the undulating fields and formalized them, getting rid of the natural perspective and giving the lane parallel sides. The hedges, which rise up towards us in the photo, were made to bend out at right angles to the lane. But although I made changes in the drawing stage, I used the layering qualities of acrylic to represent the textures and colours of the landscape. In the photo, the reflections of the sky in the puddles in the dip act as a focal point, and I made them serve the same purpose in the abstract.

Below Cheselbourne 1; Tony Paul
Acrylic, 230 x 230 mm (9 x 9 in)

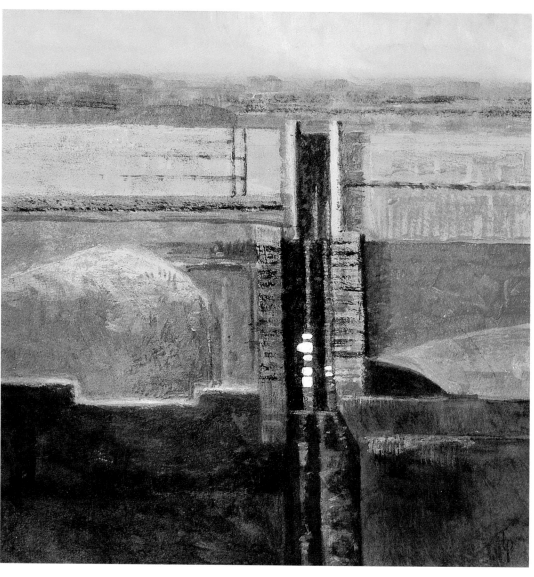

The photograph used as the basis for "Portofino 1" is a close-up of part of a fibreglass boat hull that had been rubbed down prior to being repainted. It showed several previous layers and to me had a hint of the colours and textures of the Italian coastal village of Portofino. As it was a ready-made subject, I just took it as it was and translated it into a painting with acrylic. This is one of the rare occasions when I was very literal in my representation of the photograph

Above Portofino 1; Tony Paul
Acrylic, 203 x 254 mm (8 x 10 in)

GLOSSARY

Acrylic: a quick-drying, water-mixable painting medium based on acrylic resin.

Acrylic mediums: additives that can be mixed with acrylic paint to change its character – to increase gloss, make it matt surfaced or slow its drying.

Aerial perspective: the effect where colours and tones soften and tend towards blue-grey as they recede into the background.

Alla prima: painting a picture in one session – see page 57.

Bracketing: the taking of several different exposures of a subject – see page 32.

Camera lucida: an optical copying device – see page 12.

Camera obscura: a light box that projects an image as an aid to drawing – see page 11.

Complementary colours: the colours that are directly opposite each other in the colour wheel: red/green, yellow/violet, blue/orange – see page 44.

Contre-jour: against the light – paintings made looking into the light.

Cropping: reducing the content of an image by selecting part of it – see page 35.

Depth of field: the depth of focus of a lens as modified by the aperture width.

Egg tempera: an ancient translucent medium made from pigments blended with egg yolk and diluted with water. The colours are applied thinly, often in hatched or dabbed strokes. It is characterized by its ability to give clear, glowing colours, which dry to give a semi-matt finish. Most egg tempera painters make their own paints, but Daler-Rowney supplies an excellent range of egg tempera colours in tubes.

Flare: a fogging effect created when direct sunlight enters a camera lens.

Glaze: laying a transparent colour over an underlayer. Often used in oil painting to create depth of colour, with a painting medium added to increase transparency while maintaining a good viscosity.

Gesso: a type of priming. True gesso is made from slaked gypsum or whiting, and titanium, or zinc white pigment bound together with rabbit-skin glue. It is the perfect sub-structure for egg tempera painting. As with the paint, egg tempera painters usually make their own panels – a tedious but ultimately satisfying business. A manufactured acrylic "gesso primer" is made by most manufacturers and is excellent for treating surfaces ready for oil and acrylic painting. It doesn't have the absorbency of true gesso and therefore is unsuitable for egg tempera paintings.

Golden section: a proportion in which a line or rectangle is divided into two unequal parts that give a pleasing aesthetic relationship.

Gouache or bodycolour: a highly pigmented watercolour to which an opaque filler has been added, to give it opacity. The light colours tend to dry darker than when applied, and the darks lighter. With gouache, light colours such as yellows can be painted over darks without any loss of brilliance. The colours dry to give a matt finish.

Harmonic colours: colours that lie next to one another in the colour wheel – see page 44.

Hue: there are two meanings: it can be used as another word for colour – "the roof was a reddish hue". It can also be used to describe a colour that has been made from cheaper pigments to imitate a (usually) more expensive colour – "cadmium red (hue)", for instance.

Impasto: the thick application or building up of a paint surface to give a three-dimensional effect. Most often used by painters in oil and acrylic.

ISO setting: the speed of a film or exposure rating.

Masking fluid: a latex solution that is applied to paper with an old brush, cocktail stick or pen to preserve the white paper. When dry, it resists a watercolour wash and later can be easily rubbed off to enable further layers of paint to be applied if desired.

MDF: medium-density fibreboard. A similar board to hardboard, but smooth on both sides and available in a variety of thicknesses – 6 mm is ideal. MDF is more expensive than hardboard, but offcuts can still be obtained at bargain prices from your local woodyard. Beware of cutting or sanding the boards yourself – the dust from some types of MDF can be carcinogenic.

Medium (plural media): a particular type of paint, such as oil paint, acrylic, watercolour etc. Second meaning: a liquid that can be added to a paint to improve certain characteristics, such as impasto or gloss.

Monochrome: one colour, usually a work in shades of grey or brown, but can be of any colour. Always tonal.

Oil: oil paint made from pigments ground in a drying oil, usually linseed. Sometimes poppy, safflower, walnut or sunflower oils are used in certain colours and in whites because they yellow less than linseed. It is diluted with solvents such as turpentine.

Pastel: sticks of pigment mixed with a gum binder and made in a range of tints (paler versions) and shades (darker versions). They adhere to the painting surface by being gripped in the tooth of the paper.

Primary colours: colours that cannot be mixed from other colours – reds, blues and yellows. It can also mean colours that are mono-pigments, such as viridian, which is created green, not a binary mix of blue and yellow.

Rough priming: usually acrylic gesso that has been haphazardly applied to a panel with a coarse bristle brush to create a textured surface.

Saturation: the strength of a particular colour, sometimes called the chroma. The stronger the colour, the higher degree of saturation.

Scumble: a veil of colour, usually paler, that is scrubbed over another colour to partially obliterate or modify it.

Secondary colour: orange, green and purple. Colours that are mixed from two primary colours.

Sgraffito: marks made by scratching through a painted surface.

Telephoto lens: a lens that will enlarge distant subjects.

Temperature counterpoint: the laying of a cool colour against one that is warmer, or vice versa.

Tertiary colours: mixed from a secondary colour and the remaining primary colour. These are usually dull, grey, or brownish.

Tonal counterpoint: the placing of one tone against another to make each stand away from the other.

Tooth: the texture of a surface. A paper with a good "tooth" will pull pigment from the pencil or pastel to make a strong mark. Surfaces with little tooth will give only weak colours/tones when used with dry media.

Wet-on-wet (also wet-in-wet): painting into wet paint with more wet paint. Its most popular use is in water-colour, but it can be used to effect in all "wet" media.

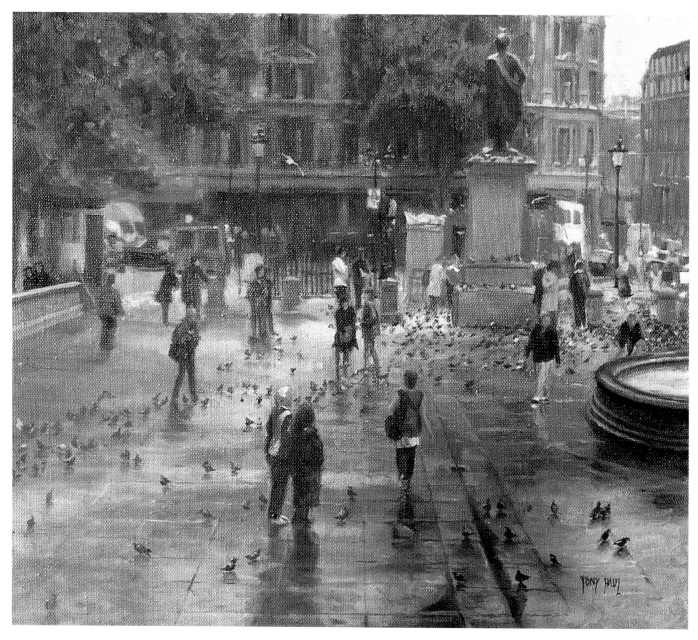

ABOVE Wet Day, Trafalgar Square, London; Tony Paul
Oil, 253 x 305 mm (10 x 12 in)

CONTRIBUTORS

Ian Aston
Olympus User Magazine
PO Box 222
Southall
Middlesex UB2 4SB
p 18 (b)

Eric Bottomley
The Old Coach House
Much Marcle
Nr. Ledbury
Herefordshire HR8 2XX
pp 93, 95, 96, 97

Marita Freeman
www.maritafreeman.co.uk
pp 24, 25

Mike Gunnell
32 Marlborough Road
Ipswich
Suffolk IP4 5AX
p 107

Rod Jenkins
St Olaves
Fairfield Road
Blandford DT11 7BZ
pp 67, 68, 69, 70, 71

Lisa Graa Jensen
45 Wodeland Avenue
Guildford
Surrey GU2 4JZ
pp 109, 110 (b), 111, 112

Peter Kelly
The Chestnuts
The Square
Stock
Essex CM4 9LH
p 59 (b)

Jonathan Newey
www.jonathannewey.bizland.com
pp 63 (b), 87

Tony Paul
Church Lane Cottage
Cheselbourne
Dorchester
Dorset DT2 7NJ
All paintings other than those listed

Alan Simpson
24 Waltham Road
Bournemouth
Dorset BH7 6PE
p 55 (b)

George Thompson
2 Hillbre Court
South Parade
West Kirby
Wirral CH48 3JU
pp 43 (b), 48 (b), 65, 72 (b), 73, 74, 79 (b)

David Wright
Greengates
Longfield Road
Dorking
Surrey RH4 3DE
pp 46 (r), 60 (r)

Teresa Zwolinska-Brzeski
Southbourne Gallery
2 Carbery Row
Bournemouth BH6 3QR
p 62 (r)

ACKNOWLEDGEMENTS

I would like to thank the following, who were all of considerable help to me in the production of this book: Firstly to the patient and thorough editing by Corinne Masciocchi, the good advice of Rosemary Wilkinson and careful design and production work of Ian Sandom and Hazel Kirkman.

My grateful thanks are extended to the artists who allowed me to use their excellent work to illustrate points and extend the artistic breadth of the book.

To Ian Aston, an excellent photographer and adviser to me on matters photographic, for his foreword. To the models who, both knowingly and unknowingly, provided the subjects for my paintings.

And finally, to my long-suffering wife Rae who has been a continuing strength and support.

INDEX

Page numbers *in italics* refer to captions

INDEX

Index